IMAGES
of Rail

AUTO-TRAIN

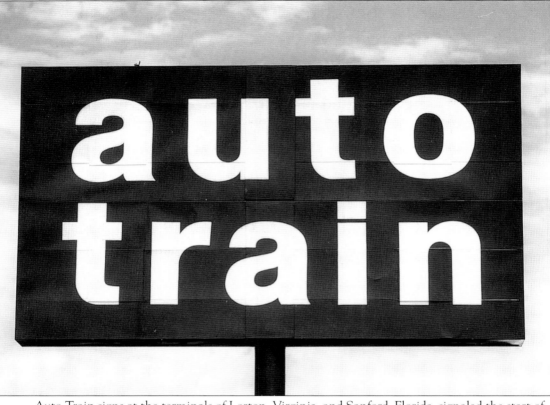

Auto Train signs at the terminals of Lorton, Virginia, and Sanford, Florida, signaled the start of a luxurious overnight adventure for families and their vehicles. (Author's collection.)

ON THE COVER: Auto-Train was known for its powerful, colorful, and distinctive GE U36B diesel-electric locomotives. They carried the Auto-Train Corporation white with red and purple color scheme. (Courtesy of Bill Folsom.)

IMAGES
of Rail

AUTO-TRAIN

Wally Ely

ARCADIA
PUBLISHING

Copyright © 2009 by Wally Ely
ISBN 978-0-7385-6785-3

Published by Arcadia Publishing
Charleston, South Carolina

Printed in the United States of America

Library of Congress Control Number: 2009921908

For all general information contact Arcadia Publishing at:
Telephone 843-853-2070
Fax 843-853-0044
E-mail sales@arcadiapublishing.com
For customer service and orders:
Toll-Free 1-888-313-2665

Visit us on the Internet at www.arcadiapublishing.com

This book is dedicated to Dr. Eugene K. Garfield. None of this—Auto Train watching, Auto Train riding, or writing a book about the Auto Train—would be possible without the creativity and perseverance of Dr. Garfield, the founder of the Auto-Train Corporation. He made it all—the successes and the failures—possible.

CONTENTS

ACKNOWLEDGMENTS

These individuals graciously provided assistance and expertise used in compiling this Auto-Train book and provided support of various kinds. The author thanks them for sharing their talents and permitting us to reproduce their work. The author acknowledges their valuable assistance. Thanks to Dave Bausch, Allentown, Pennsylvania; Bestway Printers, Allentown, Pennsylvania; Ray Burns of trainweb.com; Bill Folsom, Ponte Vedra Beach, Florida; Walt Gay, Virginia; Steve Grande of trainweb.com; Marc Grinter, Attleboro, Massachusetts; Bob Johnson, Chicago, Illinois; Matt Laviani, Ely, Nevada; Brent MacGregor; Andre Manero, Watford, Ontario; Ron Hoboron, Virginia; and J. M. Seidel, Sanford, Florida.

Kalb Photo Supply in Allentown, Pennsylvania, professionally printed many of the Auto-Train photographs from slides in the author's collection. When owners Henry and David Kalb learned a railroad book by a local author was in the making, they magically turned Auto-Train slides into prints ready for the production line at Arcadia Publishing. The Kalbs cater only to photography professionals—one doesn't take rolls of 35-mm vacation film to them for processing. The Kalbs' assistance in accomplishing a difficult assignment for the author is heartily appreciated and acknowledged.

Paul and David Hoffman of Bestway Printing in Allentown, Pennsylvania, used their scanner skills to bring a full-page newspaper advertisement down to a usable size for this Arcadia book.

Organizational help and advice relating to grammar, language, and spelling came from two very valuable and dependable sources. The author's wife, Suzanne Ely, is a retired schoolteacher. It is a blessing to have an educator at hand to read and correct writing and to advise on proper ways to present thoughts.

Then there is the author's good friend from Hellertown, Pennsylvania, Blake Heffner. Blake is the best and most picky proofreader the author has ever met. He adds or deletes commas and knows which words should be capitalized. The author would hate to give final approval to a publisher unless Blake reviewed my text.

The seven images on pages 72 through 75 are from postcards. The first five are relatively current, from the Amtrak era, bought over the years by the author at Auto-Train terminals in Lorton and Sanford. All are produced by Audio Visual Designs in Herkimer, New York. The final two antique cards are from the author's postcard collection. One other older postcard from the original Auto-Train Corporation days appears on page 31.

Unless otherwise noted, all images are from the author's collection.

INTRODUCTION

"Are You Tired of Driving Yet?" screams the billboard on I-95 in South Carolina. That says it all. It is an Amtrak advertisement.

The passengers on Auto-Train know all about that—they are sleeping or dining or reading a book as their luxury train heads for the Sunshine State.

Suzanne and I caught on to that a long time ago—we take Auto-Train at least one direction whenever we head to our timeshare at Disney World. If you are reading that billboard, you have the "pedal to the metal," and your big, tired, red eyes are glued to the highway.

The super-modern passenger train and car ferry (Auto Train) runs daily in both directions between Lorton, Virginia, just south of Washington, D.C., and Sanford, Florida, somewhat north of Orlando. It is an Amtrak train, touted as the longest passenger train in the world.

It didn't start out as Amtrak, and that is what this book is all about. How did Auto-Train originate? What happened to it? What is Amtrak doing to perpetuate this gem of a train trip? Stay with me for the next 100 or so pages and we will discuss all there is to know about Auto-Train.

If you are a rail fan or just a train traveler, there is something in here for you. We've rounded up some pretty pictures of the train—then and now.

One of my favorite experiences in compiling this book was my visit with the original Auto-Train founder, Eugene K. Garfield. Dr. Garfield's stories about his vision of a luxury auto ferry service to Florida appear throughout the book.

Thank you to the many people who went out of their way to get this book into your hands. My wife, Suzanne, tolerated immeasurable interruptions in our family life while I buried my head in the word processing program on our home computer and on my Palm Pilot. At Amtrak, Vice Pres. Joe McHugh, originally from my hometown of Allentown, Pennsylvania, stepped forward in Washington and connected me with Cliff Black, who guided me through the Amtrak hurdles.

My representative in the U.S. Congress, Charlie Dent, was responsible for obtaining some permission from Amtrak needed to proceed. Then there was Kaia Motter of Arcadia Publishing, who first gave a nod to the idea that Auto-Train was worthy of a book of its own.

At Arcadia Publishing, editor Brooksi Hudson guided my book proposal through the approval process—committees and all. Brooksi answered all my questions and monitored the progress of the book so that Arcadia deadlines would not be missed.

You may have stories to add, and I would love to hear them. An e-mail address has been set up just for the readers of this book. Write to me at WallysAutoTrain@aol.com—I read all the mail and will respond. Any other news relating to this book (and my others) may be found on my Web site. Look me up at www.WallyEly.net. As with my previous books, I keep a journal of all the comments I receive from readers.

This same Web site covers many of the short articles I have written on various topics—including "A Visit to the Amtrak Office" and "Scanning to Las Vegas." Another tip to folks who enjoy chatting about the Auto Train: you may care to explore the *Auto Train Digest* at Yahoo.com. You'll

find other folks with similar interests there. Both www.ThemeTrains.com and www.trainweb.com are full of Auto-Train pictures and worthy of a visit.

Would you believe model train builders sometimes model the Auto-Train? Bachman produced a series of HO and N Gauge scale toy trains. *Model Railroad* magazine published an article about modeling this national treasure in December 1994, but the publisher of the magazine would not permit us to reproduce any of the excellent photographs of their work. Maybe your local library will have a copy of it.

Another chance to get your fill of Auto Train is to log on to www.youtube.com and search "Auto Train." More than 100 replies will appear—select any one of them and watch this spectacular passenger train roll by!

If you are planning to ride the Auto Train, here are two tips for you from the author. First, consider buying or borrowing a scanning radio that covers railroad frequencies. Learn how to use it before you board the train. It will bring a new dimension to your travels. For a list of Auto Train railroad frequencies and other Auto Train travel tips, check out this valuable Web site: www.on-track-on-line.com. Second, take your GPS along, and don't forget the charger. What fun it is to see exactly where you are at any moment on your trip!

Thanks to my readers for rambling through these pages of Auto Train memories with me. I appreciated having the opportunity to pull all this together for you. Remember, you may reach me at WallysAutoTrain@aol.com.

Our Auto-Train conductor says we are ready to pull onto the main line. All aboard!

One

BEFORE AUTO-TRAIN

A TIMELY IDEA STRIKES EUGENE GARFIELD

Dr. Eugene Garfield took an idea borrowed from a National Transportation Department study and made it work—for a time. Dr. Garfield explained that the administration was turning over in Washington in January 1969 at the end of the term of Pres. Lyndon Johnson. Garfield's position as assistant to the Secretary of Transportation had evaporated.

On a visit to the office of Allen S. Boyd, the transportation secretary, Garfield spotted a U.S. Transportation Department report about the feasibility of an auto-ferry service between the Northeast and Florida. Garfield scanned the table of contents, liked what he saw, and wanted to learn more. He received permission from Boyd to take the study home to read it.

Dr. Garfield told this author, "The study recommended that it would be essentially profitable in the private enterprise sector. I'm an enormous advocate of private enterprise. Almost everything ought to be done by private enterprise."

Garfield was hooked. Since a career change was imminent, why not start a railroad? He did his own research. He polled his friends, especially those he had worked closely with over the time he spent in the state government in Florida. The answer came back loud and clear—"Great idea!"

Garfield started building a passenger railroad. Funding would be an early challenge. The Interstate Commerce Commission had jurisdiction over railroad stock offerings, so an ICC certificate was obtained, and the funding process was under way.

Garfield had what it takes to move forward. He had credibility thanks to his political connections and reputation as a get-it-done guy in Florida. He needed every bit of that clout as he shopped American railroads to stock his trains with serviceable equipment. He loved the Santa Fe, and this railroad had full dome cars on the block. Garfield's new company bought them. Garfield went right to the top at each of his railroad stops. He was set to deal with railroad presidents, skipping the step where lower-management types needed to get approval for every move they considered making for him. It worked. Garfield garnered help at the presidential level, and the equipment he needed began coming his way.

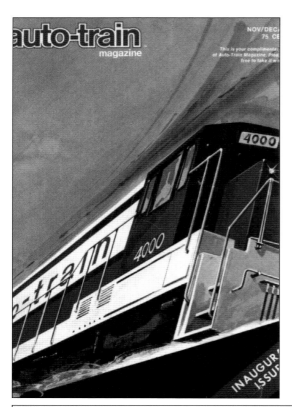

This artist's rendering of an Auto-Train diesel locomotive graced the cover of the first issue of the *Auto-Train Magazine* in 1973. The publication was distributed free to passengers on the train.

thank you for riding

auto–train

you'll never drive all the way again

This message on a bumper sticker described the Auto-Train motto and was used in company advertising for years. Many Americans agreed with it, and for them it came true.

Dr. Eugene K. Garfield was the founder of Auto-Train.

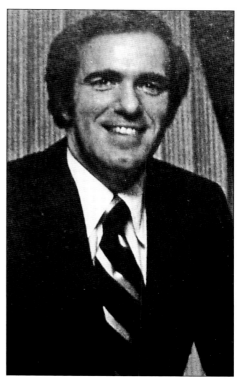

This advertisement by General Electric brags about its locomotives running on the Auto-Train. This striking rendering of the entire train in a Florida-like environment appeared in national magazines. It shows the diesel engines followed by car carriers and then the passenger coaches and sleepers.

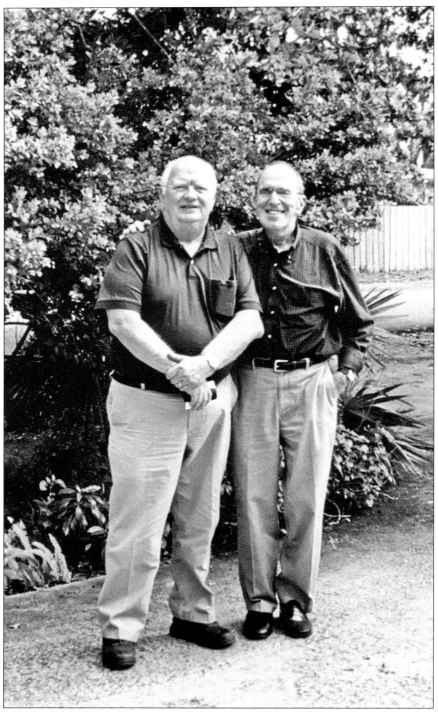

Dr. Eugene Garfield (right) chatted with the author, Wally Ely (left), at Garfield's home in Fort Lauderdale, Florida, during the author's research trip gathering data for this book. Garfield founded the Auto-Train Corporation and was chairman of the board of directors and the president.

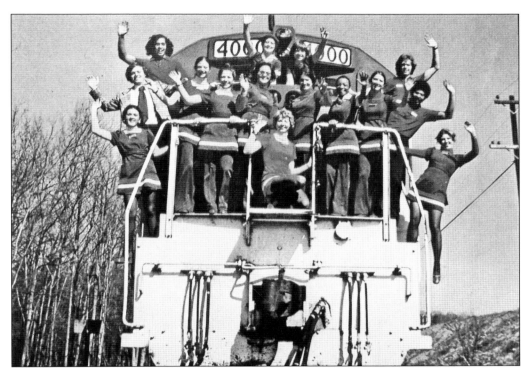

Auto-Train Corporation employees climbed aboard a company diesel engine and waved for the camera during a family portrait created for an *Auto-Train Magazine* cover.

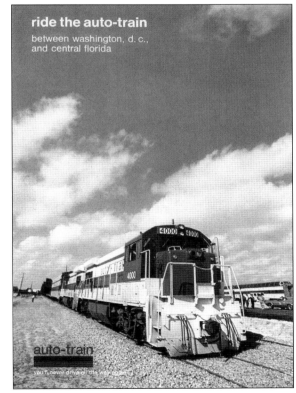

The Auto-Train message was brief in this magazine advertisement for the new railroad. Basically, "Ride The Auto-Train" says it all. This version showed off the company engine and colors in September 1972.

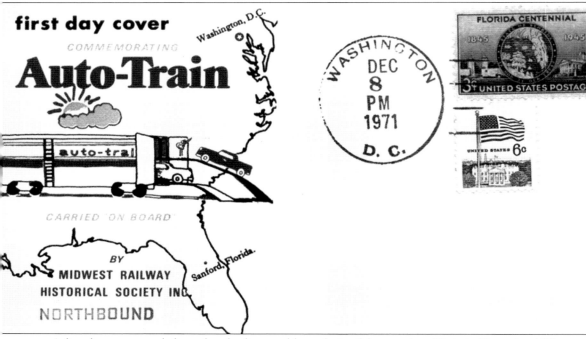

A first-day cover was dedicated to the first northbound trip of the new Auto-Train in December 1971. This envelope was postmarked December 8 in Washington, D.C. First-class postage was 9¢.

Two

Auto-Train
The Concept

Rail travelers take Auto Train for granted. A person can pick up the phone and dial 1-800-USA-RAIL anytime to book a coach or sleeper accommodation on this luxury train between Lorton, Virginia, and Sanford, Florida.

But it wasn't always that way. To travel to Florida in the winter and bring a car along meant driving Interstate 95 for upwards of 1,000 miles and sleeping overnight in a motel at least once. The trip was inconvenient, uncomfortable, and expensive.

In 1966, the U.S. Department of Transportation did a study on the potential for a dedicated Northeast-to-Florida passenger and car ferry service. The report concluded a railroad such as this could be financially viable—particularly if it was operated by private enterprise.

In Washington, in early 1969, Dr. Eugene Garfield was a victim of the changing administrations when Pres. Richard Nixon's team replaced Pres. Lyndon Johnson's. Garfield had worked as an assistant to the Secretary of Transportation. He served in the Department of Transportation as liaison for "the 54 governors." He enjoyed making this claim and waiting for people to respond, "Dr. Garfield, there are only 50 states, and 50 governors." Then Dr. Garfield would explain that he meant 50 states and four possessions.

Garfield remembers that he picked up the car ferry study from the table outside the office of Allen S. Boyd while awaiting an appointment with the Secretary of Transportation. Scanning the table of contents was enough to get him interested, so he asked the secretary's permission to borrow the study. From that day until Garfield's Auto-Train Corporation ran its first trips between Virginia and Florida in December 1971, Garfield scrambled to arrange financing for his enterprise and purchase locomotives and rolling stock for his new railroad.

Some say Garfield made the move at just the right time. Railroads all over America were reducing their inventories of passenger equipment—coaches, diners, and sleepers. Dr. Garfield himself explained to me what a lengthy and tedious project was obtaining car carriers (eventually located in Canada) then outfitting the couplers and trucks to his specifications to create a smooth ride for this precious cargo.

Cocktail napkins were served with drinks and snacks to passengers on the original Auto-Train.

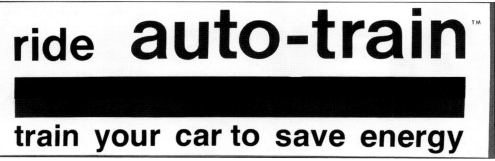

This version of an Auto-Train bumper sticker promotes the energy-saving aspects of traveling on the rails.

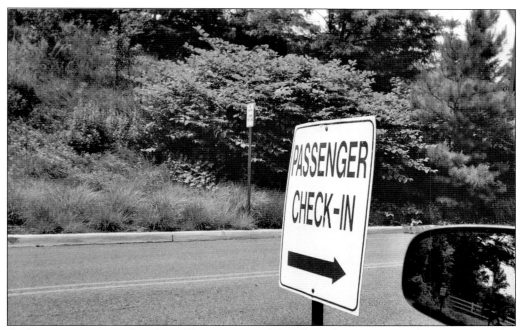

A driver arrives at the Auto-Train terminal heading for an overnight cruise on the luxury train.

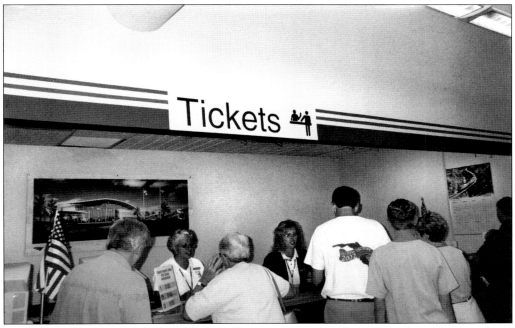

Passengers crowd around the ticket office selecting a sitting for dinner—early, medium, or late.

Strings of empty car carriers line up awaiting the loading ramps to access the three levels. Cars ride inside the carriers while passengers enjoy the treat of riding in the coaches and sleepers.

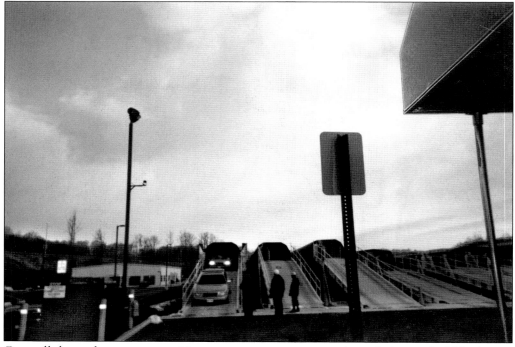

Cars roll down the ramps to waiting passengers, eager to continue their travels. Vehicles are delivered by valet drivers who remove them from the carriers.

This map is among the goodies Auto-Train gave to its passengers. The route shows 23 cities the train passes on its overnight travels. Coordinated with this is the travel time shown on the sides. Leaving Virginia, the train passes through three states (North Carolina, South Carolina, and Georgia) before reaching Florida. Everything is reversed for the northbound trip.

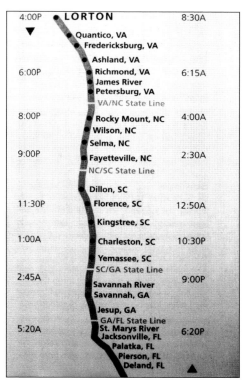

4:00P ▼	**LORTON**	8:30A
	Quantico, VA	
	Fredericksburg, VA	
	Ashland, VA	
6:00P	Richmond, VA	6:15A
	James River	
	Petersburg, VA	
	VA/NC State Line	
8:00P	Rocky Mount, NC	4:00A
	Wilson, NC	
	Selma, NC	
9:00P	Fayetteville, NC	2:30A
	NC/SC State Line	
	Dillon, SC	
11:30P	Florence, SC	12:50A
	Kingstree, SC	
1:00A	Charleston, SC	10:30P
	Yemassee, SC	
	SC/GA State Line	
2:45A	Savannah River	9:00P
	Savannah, GA	
	Jesup, GA	
	GA/FL State Line	
5:20A	St. Marys River	6:20P
	Jacksonville, FL	
	Palatka, FL	
	Pierson, FL	
	Deland, FL ▲	

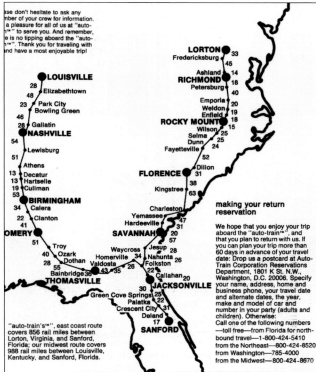

ase don't hesitate to ask any nber of your crew for information. a pleasure for all of us at "auto-n'*" to serve you. And remember, e is no tipping aboard the "auto-n'*". Thank you for traveling with nd have a most enjoyable trip!

LOUISVILLE
28
48 Elizabethtown
23 Park City
Bowling Green
46
28 Gallatin
NASHVILLE
54
51 Lewisburg
Athens
13 Decatur
13 Hartselle
19 Cullman
53
BIRMINGHAM
34 Calera
22 Clanton
41
OMERY
51 Troy
40 Ozark
28 Dothan
55 Bainbridge 36
THOMASVILLE

LORTON 33
Fredericksburg
45
Ashland 14
RICHMOND 18
Petersburg 40
Emporia 20
Weldon 19
Enfield 18
ROCKY MOUNT 15
Wilson
Selma 25
Dunn 24
Fayetteville 52
Dillon 31
FLORENCE
38
Kingstree 63
Charleston
Yemassee 47
Hardeeville 31
SAVANNAH 20
57
Waycross Jesup 28
Homerville 34 Nahunta 26
Valdosta 26 Folkston
43 35 22 Callahan 20
JACKSONVILLE
Green Cove Springs 25
Palatka 22
Crescent City 31
Deland 17
SANFORD

"auto-train's'*", east coast route covers 856 rail miles between Lorton, Virginia, and Sanford, Florida; our midwest route covers 988 rail miles between Louisville, Kentucky, and Sanford, Florida.

making your return reservation

We hope that you enjoy your trip aboard the "auto-train'*", and that you plan to return with us. If you can plan your trip more than 60 days in advance of your travel date: Drop us a postcard at Auto-Train Corporation Reservations Department, 1801 K St. N.W., Washington, D.C. 20006. Specify your name, address, home and business phone, your travel date and alternate dates, the year, make and model of car and number in your party (adults and children). Otherwise:
Call one of the following numbers —toll free—from Florida for north-bound travel—1-800-424-5410 from the Northeast—800-424-8520 from Washington—785-4000 from the Midwest—800-424-8670

During the time the Auto-Train Corporation expanded to include a "Midwest route" from Louisville, Kentucky, the map of the line looked like this. The expansion route did not enjoy the successes of the main Lorton, Virginia, to Sanford, Florida, route and was shut down early. The passenger Auto-Train was not very compatible with the largely freight Louisville and Nashville railroad host.

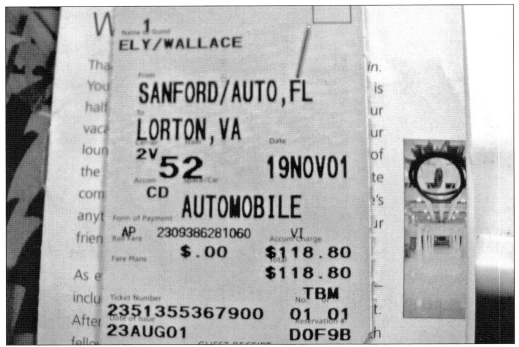

This car had a train ticket—just like a person. On the Auto Train, that is possible, since it ferries people and their cars.

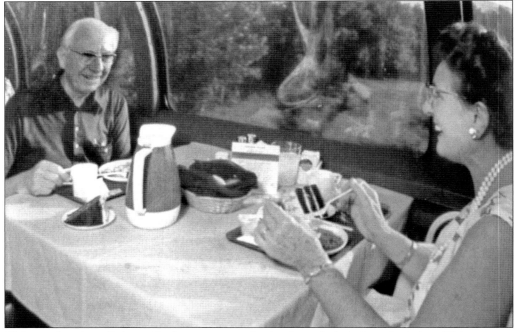

This couple enjoys dining with the scenery passing by through their domed window. This was part of the Auto Train experience that everyone appreciates and remembers. (Courtesy of Amtrak.)

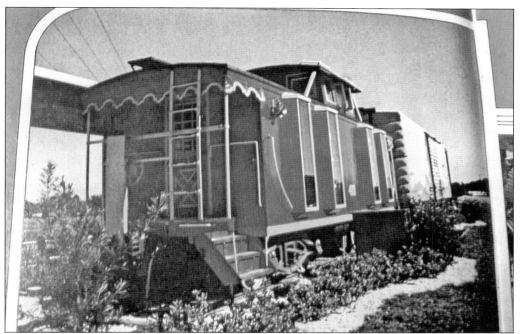

The original Auto-Train did not just have a gift shop, they had a "boutique." In fact, a boutique could be found at each terminal.

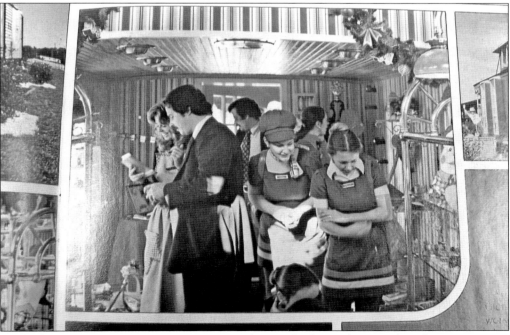

Inside the Auto-Train Boutique, company employees check out the new place for passengers to shop as part of their train trip. The shop was bright, colorful, and different, just like everything else the corporation did.

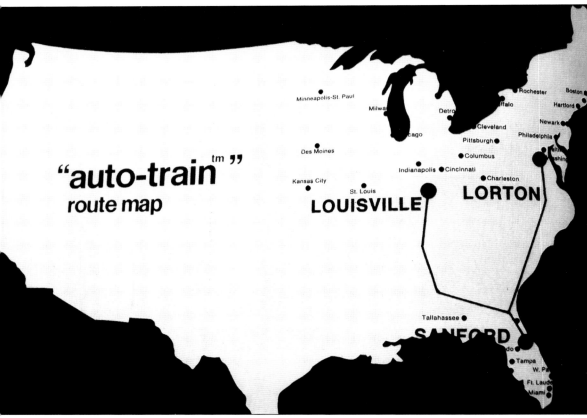

The *Auto-Train Magazine* included a route map of the luxury passenger trains. This map orients the reader to the locations of Louisville, Lorton, and Sanford. This map from the 1970s would be quite different today, since there is no Auto Train service to Louisville—just Lorton and Sanford.

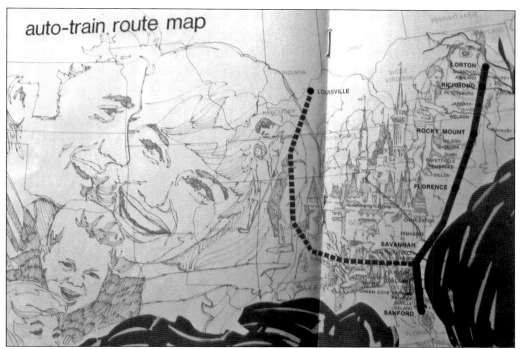

Another version of the Auto-Train route map traces the high points of the train path from Virginia and Kentucky to Sanford, Florida.

Travelers heading to the Auto-Train terminal can hardly wait to see this sign: "Auto-Train Terminal Next Exit." It is right there along I-95 in Virginia south of Washington, D.C.

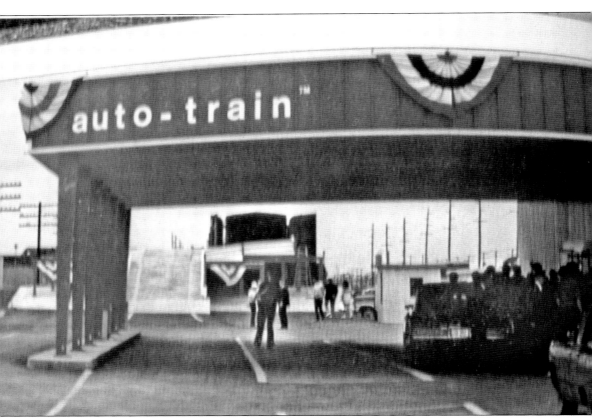

When Auto-Train began in 1970, the grand opening was highly festive. The open doors of a car carrier can be seen in the background, with a set of car ramps in front of that. Bunting highlighted the celebration.

Three

ON THE RAILS
AUTO-TRAIN EQUIPMENT

Dr. Eugene Garfield's new Auto-Train Corporation needed plenty of railroad equipment—enough for two complete trains running north and south every day, plus spares during repairs and maintenance. His quest for train cars came at a time when railroads all over the country were disposing of passenger equipment, as passenger service was disappearing.

Garfield shared these thoughts with the author: "Each purchase I dealt with the president of the railroad. I felt that what I was trying to do was so boldly different that if I went to middle level staff it would never get done for a couple of reasons. They wouldn't have the jurisdiction and authority and number two they'd be afraid. So I called each president of each railroad that I wanted to buy cars from. Each one was supportive."

Thanks to this unique shopping method, Garfield filled his trains with modern passenger equipment—coaches, sleepers, and dining cars. The biggest challenge came from finding the automobile carriers. Garfield's standards were out of sight.

There were car carriers on the market, but Garfield determined that he could not use most of them because he had two requirements: "Circus-style" loading and passenger car trucks.

Garfield reflected back on these two details. Circus style required bifold doors. This was not easy to find, but Garfield's search went around the world. "I wanted passenger trucks under all the auto carriers—the suspension system. I want the cars to ride as comfortable as the Pullman passengers sleeping in the berths. I found them in Canada. I went up in a snowstorm—I drove up there to Montreal and bought 28 auto carrier bilevels, paid cash, and brought them home. And then went to Pullman and had them renovate the carriers. I can't tell you how many times I heard 'It can't be done.' The other thing we needed was a different type of coupler. All those cars had freight couplers. I needed passenger car couplers."

Garfield credits the lively company color scheme to a designer who worked for the company. He said, "I hired a young designer—she came to me with these designs, she said, 'Gene your trains should be red white and purple.' I said, 'you're crazy.' She said, 'You're crazier than I am.' Carol Settles—I haven't seen her for I don't know how many years. But I must tell you she is a brilliant artist."

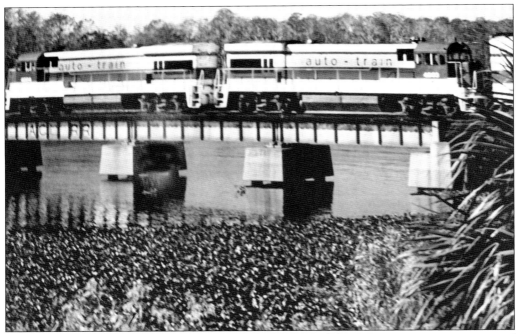

Auto-Train diesel-electric locomotives are shown on one of the many picturesque crossings of streams and rivers between Sanford and Lorton.

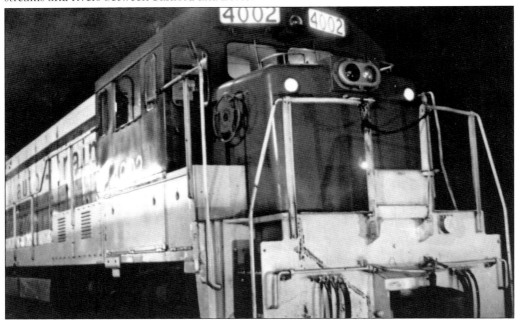

Numbered from 4000 to 4012, the General Electric U36B diesel locomotives were easily recognizable in a crowd. They sported the purple, red, and white color scheme of the company. Auto-Train locomotive No. 4002 poses on an overnight stop in Florence, South Carolina. This was one of several brief stops for service and crew changes on this through train traveling 900 miles between Virginia and Florida.

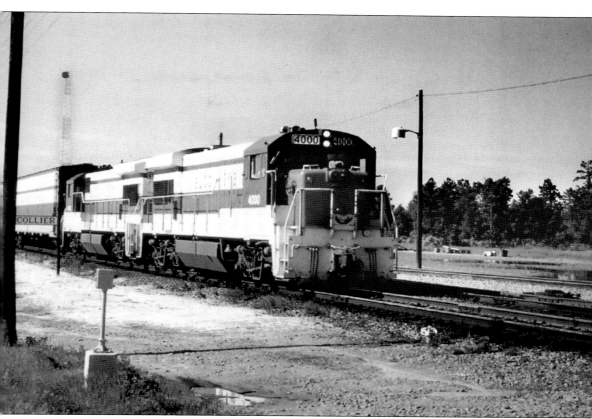

Northbound through the Collier yards near Petersburg, Virginia, original Auto-Train locomotive No. 4000 can be seen as one of two engines attached to the car carriers. This is truly a historic photograph. The photographer states that he took this picture on the first northbound run of the train when it started up in December 1971. This is a great train-watching site that is popular with railfans for continuously showing off freight and passenger trains. Visitors should pop into the "railfans parking lot" when Auto Train is scheduled and bring their cameras. (Photograph by Walt Gay.)

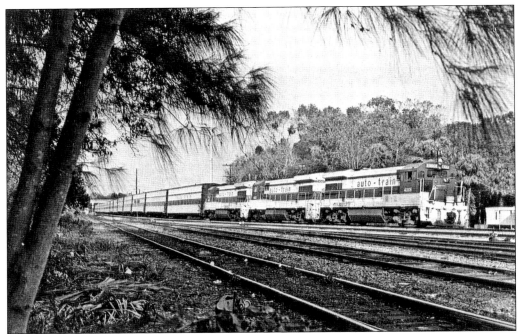

Three Auto-Train GE U36B locomotives haul train No. 3 southbound along the Seaboard Coast Line. Nos. 4000, 4006, and 4009 provide the power. Greenery is everywhere as Auto-Train passengers awake to their new environment in Florida.

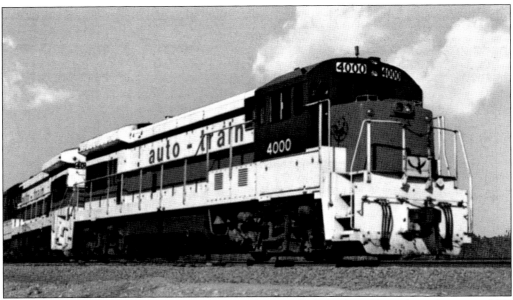

Idling along at the Lorton terminal at the northern end of the Auto-Train line, this pair of GE diesel engines prepares for the 18-hour overnight trip to Sanford, Florida.

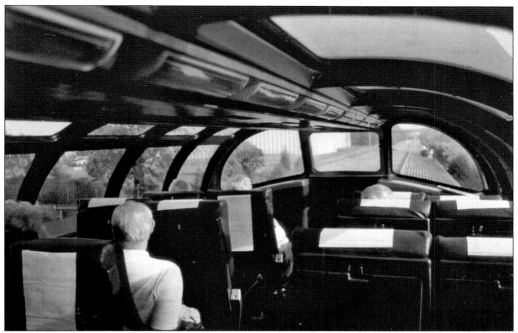

Auto-Train passengers relax in the lounge on the upper level of a dome car. The original Auto-Train bought dome cars from Western railroads such as the Santa Fe, Western Pacific, and Union Pacific. These railroads were leaving the passenger business just as Auto-Train began.

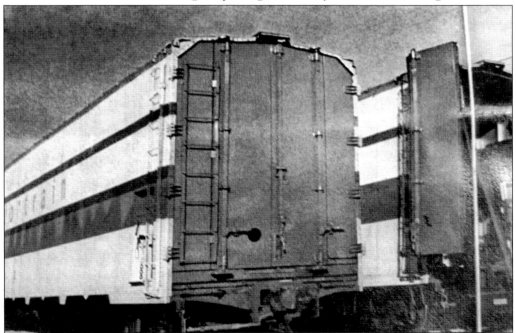

Car carriers are what set Auto-Train apart from regular passenger trains. These carriers came from Canada and were refitted with new trucks and couplers to make for a smooth ride on the way to and from Florida.

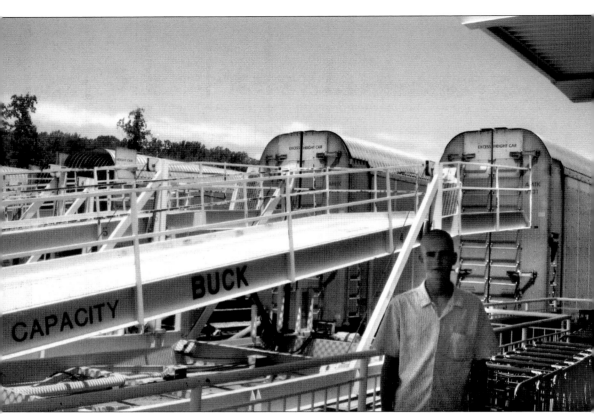

Auto Train car carriers were upgraded to trilevel in 2008, replacing most of the original carriers from the original Auto-Train Corporation days. Here the ramps can be seen clearly stationed in place and ready for loading.

This postcard of the original Auto-Train shows the beautiful dome car crossing a bridge, a vehicle being loaded into a car carrier, passengers enjoying entertainment in the lounge, an Auto-Train hostess patrolling a coach, and dinner being served in the buffet of the diner. The author owns a collection of 30 of these postcards and will send one free to readers of this book for the cost of a stamp while they last. E-mail WallysAutoTrain@aol.com to confirm availability and make arrangements.

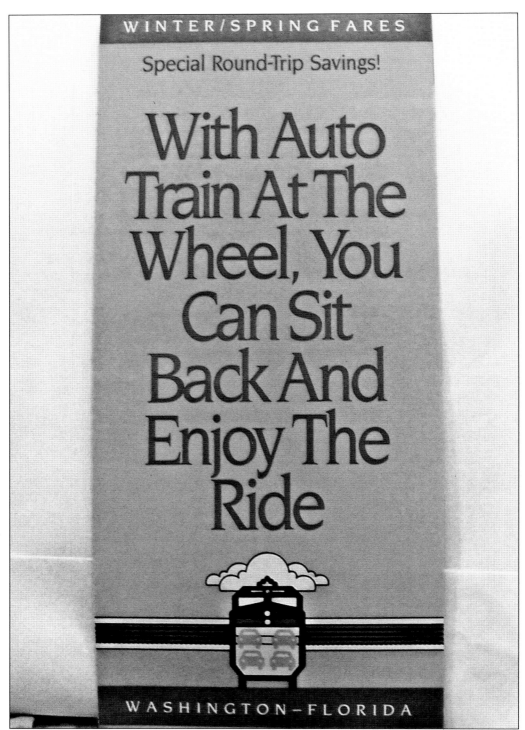

WINTER/SPRING FARES

Special Round-Trip Savings!

With Auto Train At The Wheel, You Can Sit Back And Enjoy The Ride

WASHINGTON–FLORIDA

An Auto Train brochure touts the relaxing nature of a train trip between Washington and Florida.

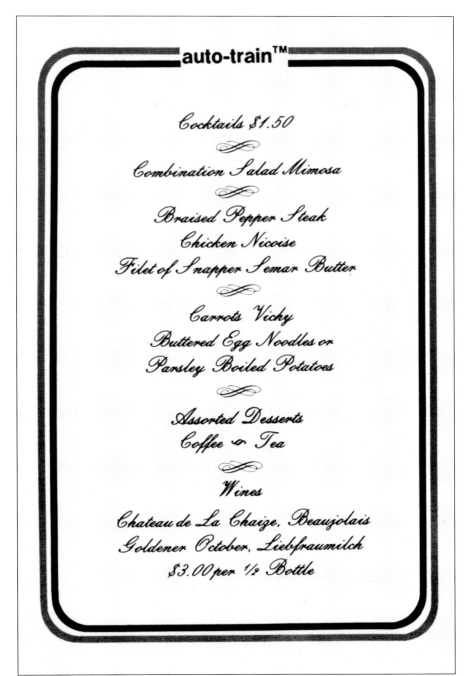

auto-train™

Cocktails $1.50

Combination Salad Mimosa

Braised Pepper Steak
Chicken Nicoise
Filet of Snapper Semar Butter

Carrots Vichy
Buttered Egg Noodles or
Parsley Boiled Potatoes

Assorted Desserts
Coffee or Tea

Wines
Chateau de La Chaize, Beaujolais
Goldener October, Liebfraumilch
$3.00 per ½ Bottle

Here is an example of the classy menu dining car passengers received on the original Auto-Train. Basically blue ink on white stock, the menu reads, "Cocktails $1.50. Combination Salad Mimosa. Braised Pepper Steak, Chicken Nicoise, Filet of Snapper Semar Butter. Carrots Vichy, Buttered Egg Noodles, Parsley Boiled Potatoes. Assorted Desserts. Coffee or Tea. Wines Chateau de La Chaige, Beaujolais, Goldner October, Liebfraumilch. $3.00 per ½ Bottle." This was certainly not fast food or cheap buffet fare.

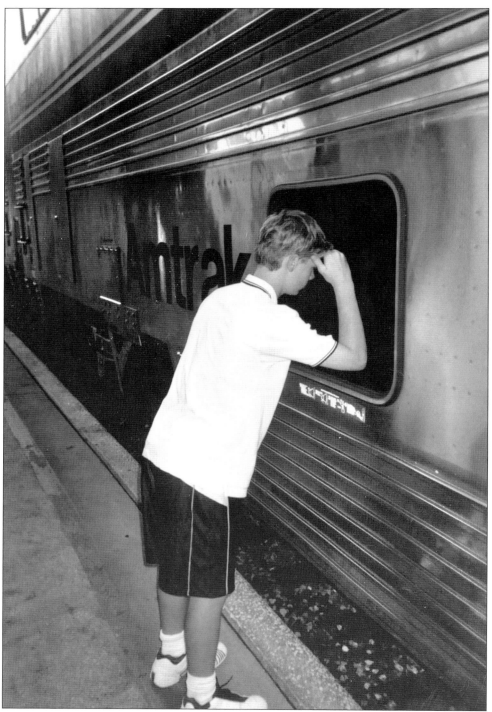

Richard Ely, the author's grandson, learned that his compartment was just on the other side of this dark window. He could not wait to get inside to settle down in the plush seats to read a book or play a game. The double-deck sleepers are an attraction worth waiting for.

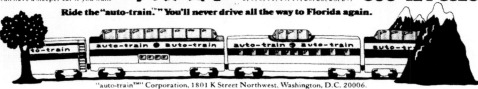

This full-page advertisement appeared in Midwest newspapers in the 1970s, when the Louisville segment of Auto-Train was introduced. The family pictured in the advertisement shows the author's wife, Suzanne; his daughter, Linda; and his nephew Richard Havir during an Auto-Train trip to Florida and Disney World. The unsuccessful experiment with expansion lasted from 1974 to 1977.

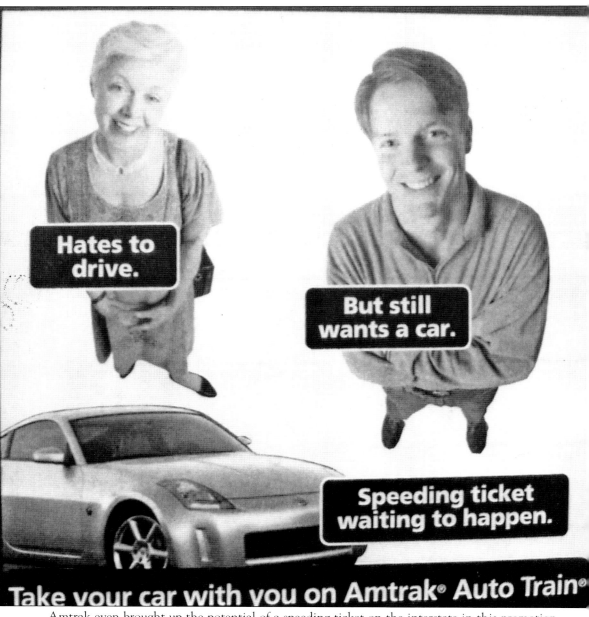

Amtrak even brought up the potential of a speeding ticket on the interstate in this promotion of the Auto Train.

here is your auto-train ticket

may we take this opportunity to wish you a very pleasant trip aboard the Auto-Train and ask that you assist us in that regard by following these very simple guidelines.

1. please time your arrival at the Auto-Train terminal *two (2) hours prior to your scheduled departure time* • a terminal expansion program is underway; however existing terminal facilities make it very difficult to process passengers until two (2) hours before departure time • our personnel will begin loading automobiles aboard the auto-carriers at that time • please note that no automobile will be accepted for transport after one (1) hour prior to the scheduled departure time.

2. should you be delayed due to adverse weather conditions or automobile difficulty please telephone the terminal from which you are scheduled to depart:

 lorton, va. — (703-690-1616) sanford, fla. — (305-323-4800)

if you miss your Auto-Train because of circumstances beyond your control, we will make every effort to schedule you on the next available train.

auto-train

Here is an original Auto-Train ticket jacket. Along with the train tickets for the trip, passengers received this note explaining details of times to arrive at the station and what to do in case the passenger is delayed on the way to the station.

Days Inn displayed a tent card promoting Auto Train. The message with this photograph stated "the drive back on I-95. The boredom, the fatigue, the less-than-scenic scenery. All over again. Instead, transport your car on board Amtrak Auto Train. Where you can eat, sleep, watch movies, or simply relish the fact that I-95 is far, far behind. And, as always, your satisfaction is guaranteed. For reservations, call Amtrak at 1-877-SKIP-I95."

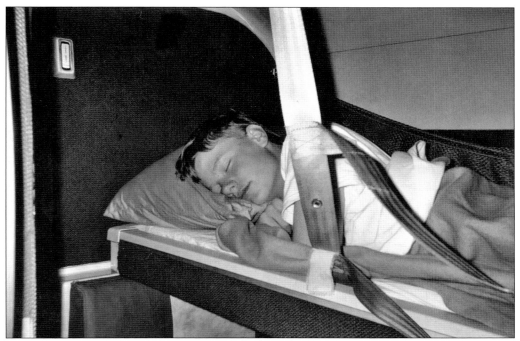

Sleeping in the upper berth as Auto-Train rolls through five southeastern states, this lad does not miss barreling down I-95 one bit!

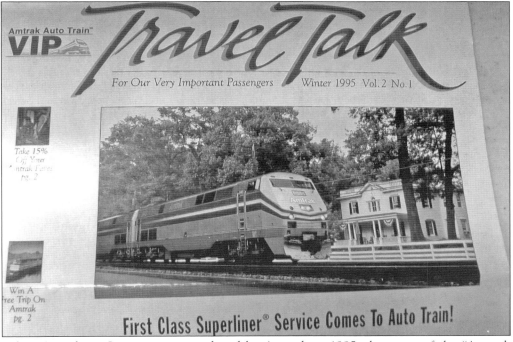

When Superliner Service was introduced by Amtrak in 1995, this issue of the "Amtrak Auto Train Travel Talk (For Our Very Important Passengers)" announced the arrival of the new equipment.

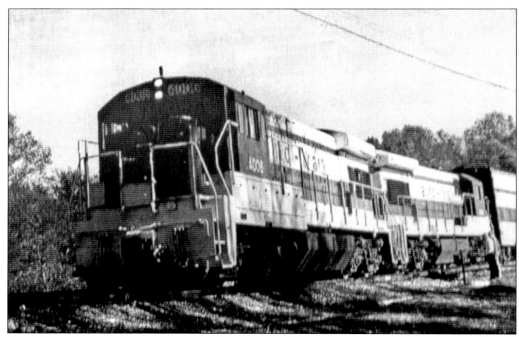

Auto-Train Corporation engines were distinctive in their color scheme. The white, purple, and red made them stand out from the rest of the industry.

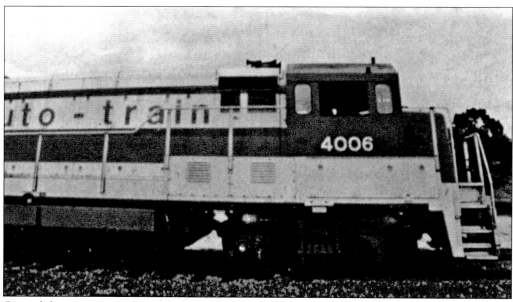

One of the Auto-Train fleet of "U-Boat" locomotives is No. 4006. This series of diesel-electric General Electric engines carried the Auto-Train fleet from Sanford to Lorton and back daily until 1981, when the company went out of business.

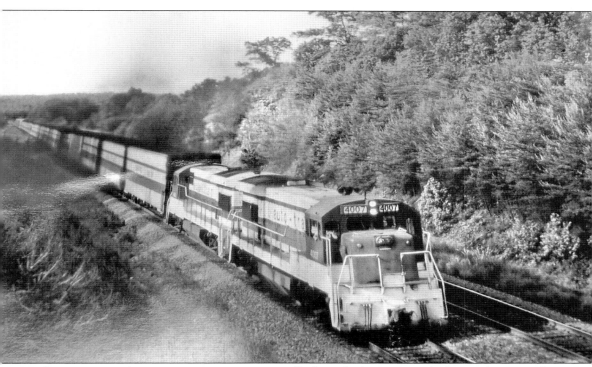

This train set makes a pretty appearance as it rolls through the countryside during the original Auto-Train Corporation days. Notice that at this time, the car carriers came first and the coaches were father back. This was later reversed, making a smoother ride for the passengers.

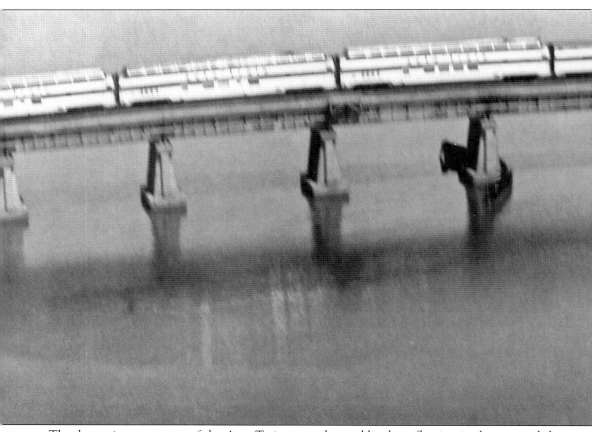

The dramatic appearance of the Auto-Train was enhanced by the reflection in the water while crossing this bridge in Virginia.

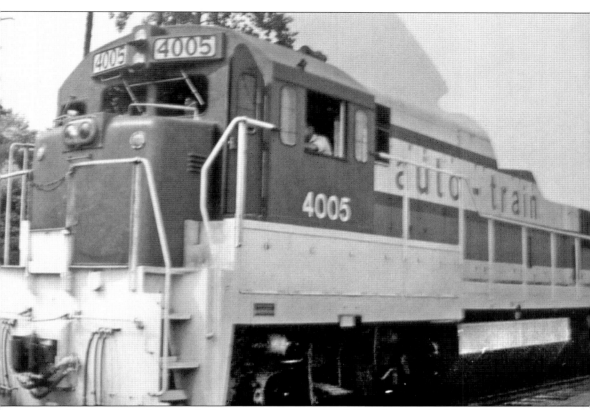

Auto-Train engines always looked clean and ready to travel. Here locomotive No. 4005 connects to the Florida-bound consist before leaving for the overnight trip to Sanford.

TRAVEL TALK

WAKE UP TO THE ADVANTAGES OF AMTRAK'S SLEEPING CARS

SUPER SAVINGS FOR NORTHBOUND TRAVELERS! Starting October 1, northbound travelers can save 34% over regular Sleeping Car accommodation rates.

For the ultimate in traveling ease and comfort, book a sleeping car on Amtrak's Auto Train and see just how relaxing and enjoyable Amtrak's Auto Train can be.

Get that added measure of comfort, privacy and personal attention by reserving a one-passenger roomette or a two-passenger bedroom. Whichever you choose, your accommodations convert easily to a sleeping compartment with private lavatory and individual temperature controls. It's like having all the comforts of home…and more.

Your special treatment starts the moment you board. Complimentary wine, Trak Snacks and a stationery package await you in your room. A special Sleeping Car Attendant is there for your convenience to prepare your room for daytime or nighttime use, as well as help you with your luggage or arrange to have your shoes shined.

And your Attendant is always on hand to bring room service orders from the Lounge. To top it all off, there's even a bedtime sweet on your pillow.

RIDE AUTO TRAIN THIS FALL AND SAVE

In 1986, Amtrak promoted the advantages of riding to Florida in a roomette or two-passenger bedroom. This issue of Auto Train's "Travel Talk" pictured the bunk bed arrangements and observed, "For the ultimate in traveling ease and comfort, book a sleeping car on Amtrak's Auto train and see just how relaxing and enjoyable Amtrak's Auto Train can be."

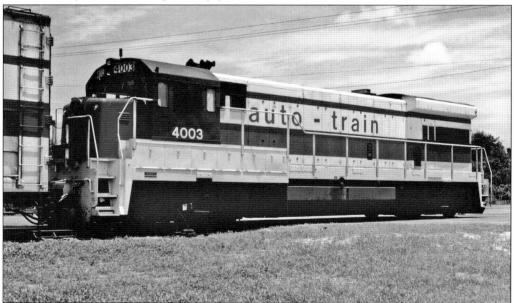

Pictured here is another stable of GE locomotives operated by the Auto-Train Corporation. No. 4003 is connected to a car carrier just before pulling its cargo onto the main line and off on an overnight adventure.

Four

AUTO-TRAIN OPERATIONS
THE EXPERIENCE

The experience of a traveler on the original Auto-Train was unlike anything elsewhere on this continent. Dr. Eugene Garfield saw to it that passengers were treated to an exotic event when they traveled on his train.

What could be so different—isn't one train ride the same as the next? Garfield to this day brags about the young crew he hired to serve the passengers. He did what he could to make them happy. When he picked up on the long walk the crew had to face getting from one end of the train to the other at the two station platforms, Garfield headed to a sports store in a mall in Orlando and bought roller skates for all of them.

The corporation looked upon the nightly trip as a visit to a nightclub, a classy restaurant, a movie theater, a first-class hotel, or all of the above. Garfield's "hotel rooms" even had televisions included to make folks feel at home.

Meals in the diner were served by "sittings," and riders could choose to eat early or late. For diversion, an Auto-Train hostess became the caller for a bingo game among the passengers. Every night after dinner, a current movie was shown in the lounge. The film began right after dinner and was played twice. These movies usually were rated PG, and the crowds in the makeshift theater included the entire traveling families.

The long ride gave others the opportunity to catch up on their reading—books and magazines could be seen in every compartment and coach seat. Snacks were available all night, and coffee pots were kept fresh for those who preferred a cup during the ride.

Although some of the amenities have changed slightly under Amtrak, a high level of customer service continues, and the train is the pride of the Amtrak fleet.

The train was and is long. Officially, Amtrak claims the train is ¾-mile long, made up of 18 passenger cars and 33 auto carriers, plus 2 engines. These numbers qualify it for the title of the "longest passenger train in the world." Auto Train carries about 650 passengers plus 330 automobiles on a full trip.

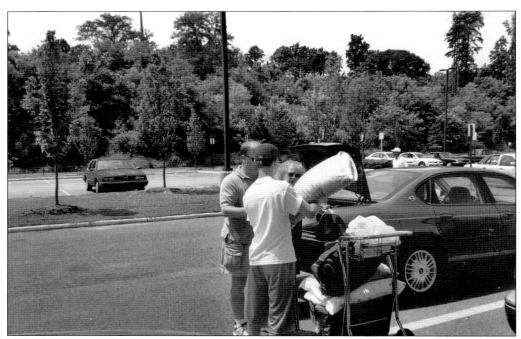

A family arrives at the Auto-Train station in Sanford, Florida, and loads just the essentials for the overnight trip onto a baggage cart. Everything else rides inside the car and cannot be accessed until arrival at the destination the next morning.

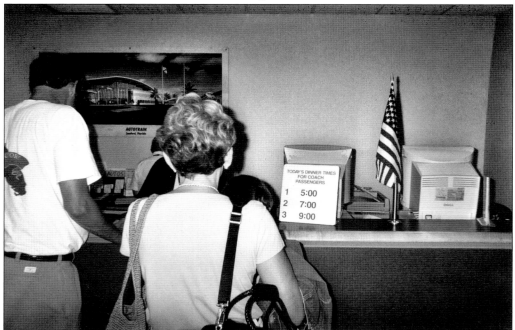

The three choices on this train for dinner with coach accommodations were 5:00, 7:00, and 9:00. Passengers could take their pick and be ready to head for the dining car when their mealtime came around.

The auto carriers are switched to their side tracks for unloading after arrival at Lorton and Sanford.

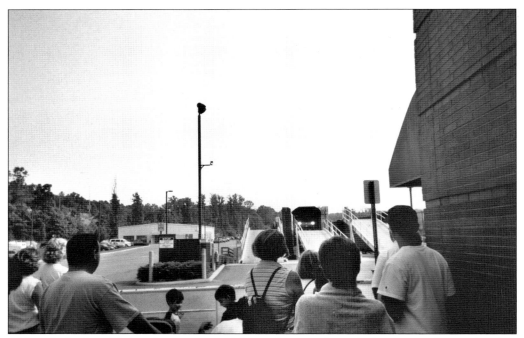

Although the Auto-Train valets move as quickly as they can, the wait always seems longer than it is thanks to the anticipation of getting rolling again. Passengers from the recently arrived train peer up the ramps and into the car carriers, hoping their car will emerge next from the darkness.

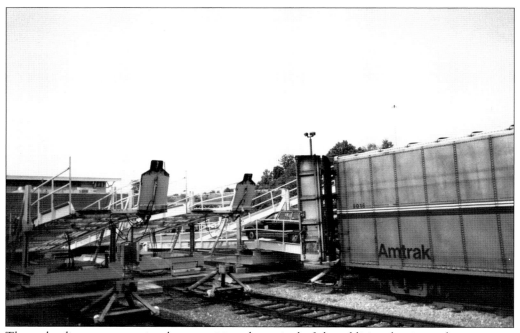

The unloading ramps are in place, awaiting the arrival of the additional strings of car carriers, which are being disbursed from the newly arrived Auto-Train. One carrier is already in place with doors open, ready to unload its cargo of automobiles.

The Auto-Train is due in soon, and the unloading ramps for the car carriers are in place awaiting the bustle of vehicles rejoining their passengers at the station.

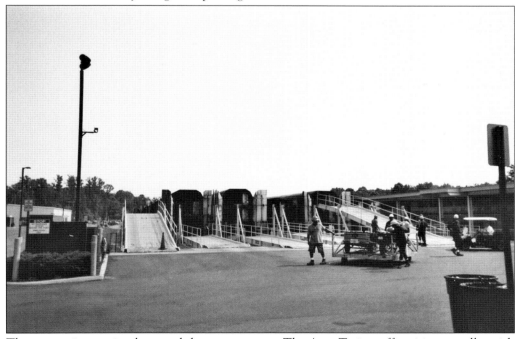

The car carriers are in place, and the ramps are set. The Auto-Train staff positions a pallet with motorcycles and a trailer ready for admission to its overnight home while the drivers take advantage of a restful night in the comfy train coaches or sleepers.

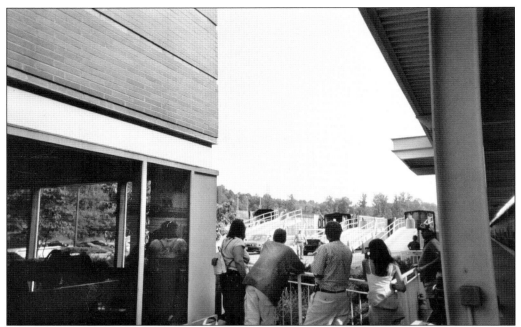

This is another view of the patrons waiting for their cars to arrive in strings of car carriers after an overnight trip on Auto-Train. The carriers will match up with the ramps for swift unloading.

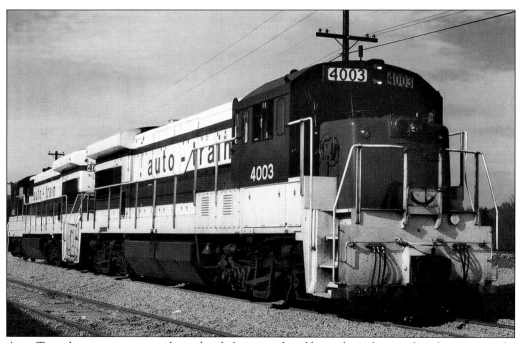

Auto-Train locomotives were always brightly painted and kept clean despite their long overnight runs up and down the East Coast. Here diesel engine No. 4003 poses in tandem with its partner, another U236B General Electric.

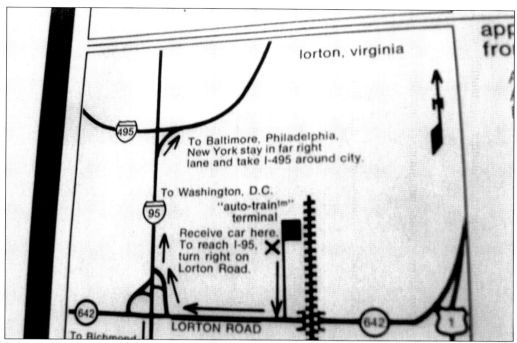

A map included with the passengers' *Auto-Train Magazine* located the station at Lorton. It showed the building and the tracks in relation to I-95, Route 1, and Route 642 (Lorton Road).

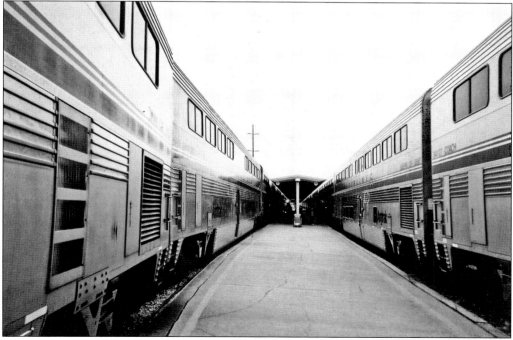

Two strings of coaches and sleepers wait on parallel tracks along the Auto Train platform.

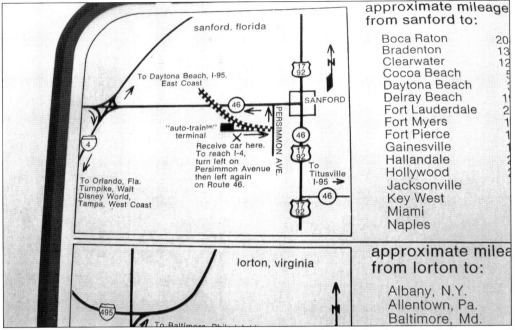

approximate mileage from sanford to:	
Boca Raton	20
Bradenton	13
Clearwater	12
Cocoa Beach	5
Daytona Beach	3
Delray Beach	1
Fort Lauderdale	2
Fort Myers	1
Fort Pierce	1
Gainesville	
Hallandale	2
Hollywood	2
Jacksonville	
Key West	
Miami	
Naples	

approximate milea from lorton to:

Albany, N.Y.
Allentown, Pa.
Baltimore, Md.

The Auto-Train map passengers received in their magazine helped the drivers find their way off the Sanford terminal property after they returned to their cars. The map shows the major routes around Sanford and how to get back to Interstate 4.

The cars in which you are riding, some of the most recent equipment built in the United States, were purchased by "auto-train™" from the Santa Fe Railroad (full-dome coaches) and the Union Pacific and Western will back up to make this connection. A slight "bump" will be felt when the connection takes place. A brake test is then undertaken to insure that this system is in faultless working order. The "auto-train™" along with many

Here infor whic more

Y the on t exte ly b ava be

Even the most experienced train traveler might appreciate a few tips, especially when riding a unique passenger train like the Auto-Train. In the company magazine for passengers, a page full of tips helped everyone acclimate to their new surroundings.

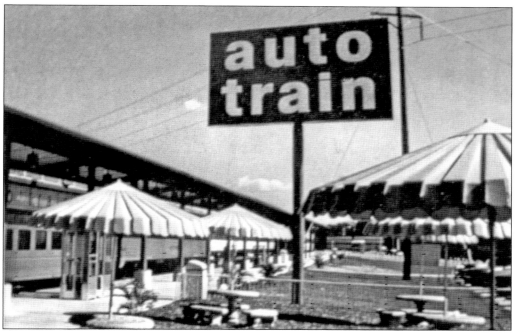

It almost looks like a festival is about to begin, but it is the patio of the Auto Train terminal adjacent to the passenger platform and the string of coaches. Here passengers can relax before boarding the overnight train.

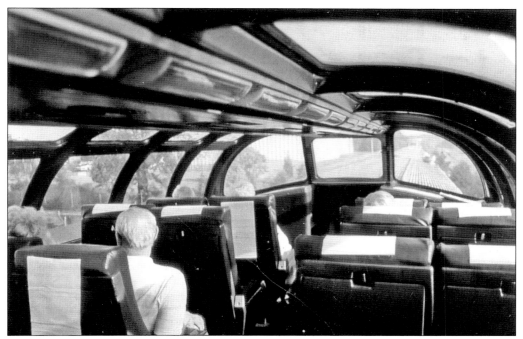

Comfortable seats in the upper level of a dome car make for a pleasant place to relax on the Auto Train. A great view overlooks the train and the passing countryside.

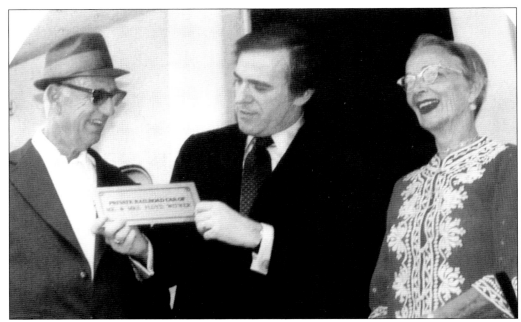

The numbers add up fast. Dr. Eugene Garfield, founder of Auto-Train, presents a surprise award to Mr. and Mrs. Floyd Witwer from Sanford, Florida, in recognition of their role as the two-millionth passengers on the luxury car ferry service. Auto-Train hit the two million mark on April 9, 1980.

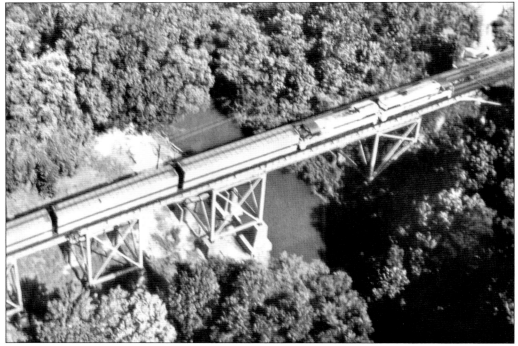

This overhead shot of the Auto-Train en route to Florida from Virginia gives a glimpse of the dramatic scenery passengers enjoy while relaxing or eating on the train. (Courtesy of Amtrak.)

Five

SHIRTS BLANTON
A SPECIAL AUTO-TRAIN FRIEND

Only the oldest Auto-Train fans can identify with the name "Shirts Blanton." Shirts was an Auto-Train institution in the early days, and a national magazine chronicled his relationship with the railroad in his front yard and Auto-Train in particular.

Blanton lived in Ashland, Virginia, on Center Street, right along the main Amtrak/Auto-Train route. His residence was across the tracks from Randolph-Macon College and just up the street from the Ashland passenger station.

Two Auto-Trains passed Blanton's door every day. Shirts became a human railroad defect-detector and assumed the job of volunteer safety-inspector. He stationed his wheelchair on his front porch, just a few dozen yards back from the tracks, when the train was due. (Blanton was recovering from near-fatal gunshot wounds suffered as he heroically saved coworkers during a robbery incident.) He viewed every passing part of the Auto-Train consist, from the engine to the caboose. The on-board railroad crew and the passenger service crew watched for Blanton's highball wave when he reported "all clear."

On board, the Auto-Train train passenger service crew informed travelers to look out for Blanton and his cheery wave. The author and his family remember pressing their noses against the windows and waving back to this tireless gentleman who devoted himself to monitoring the railroad trains passing his door.

On December 24, 1972, Auto-Train president Eugene Garfield arranged for the entire Auto-Train to stop in front of Blanton's porch. The passenger service crew jumped down from the train and ran to meet Blanton. Auto-Train carried a surprise Christmas gift for Shirts—a brand-new television. They sang Christmas carols with Shirts. An editor from *Parade* magazine was on board and covered the story, giving Auto-Train and Shirts Blanton national acclaim for their unique relationship.

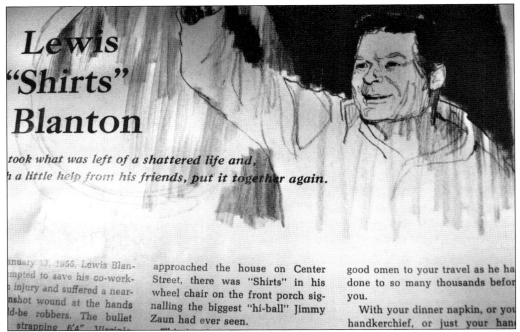

Lewis "Shirts" Blanton

took what was left of a shattered life and,
...h a little help from his friends, put it together again.

...nuary 13, 1955, Lewis Blan-
...mpted to save his co-work-
... injury and suffered a near-
...nshot wound at the hands
...d-be robbers. The bullet
...strapping 6'4" Virginia...

approached the house on Center
Street, there was "Shirts" in his
wheel chair on the front porch sig-
nalling the biggest "hi-ball" Jimmy
Zaun had ever seen.

good omen to your travel as he ha...
done to so many thousands befor...
you.

With your dinner napkin, or you...
handkerchief, or just your han...

Shirts Blanton befriended Auto-Train and monitored its passing twice every day from the back porch of his Ashland, Virginia, home. Train crew members admired the dedication of this wheelchair-bound friend and welcomed his attention to their travels.

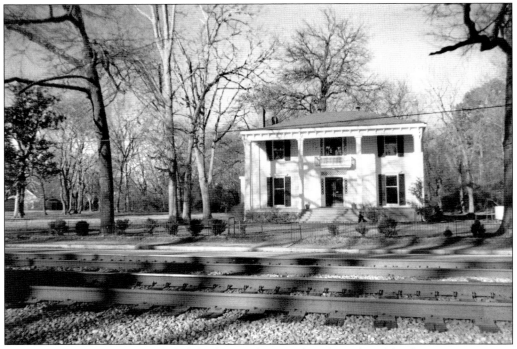

Shirts Blanton's residence sat slightly back from the main line through Ashland, Virginia—Center Street in Ashland is shown here between the tracks and Blanton's home.

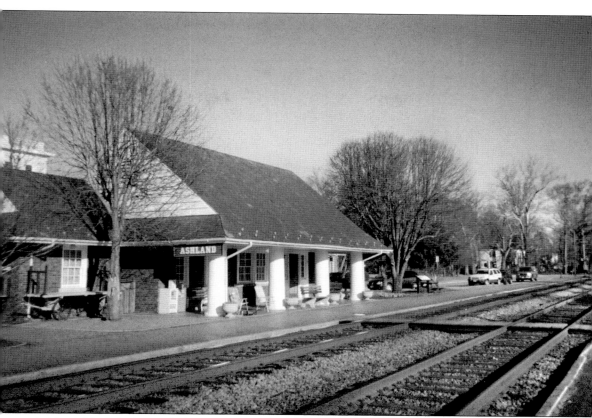

Ashland, Virginia, is proud of its passenger railroad station. It contains a library of the community, and the librarian on duty can be counted on to answer anything about the town or the trains—or even Shirts Blanton.

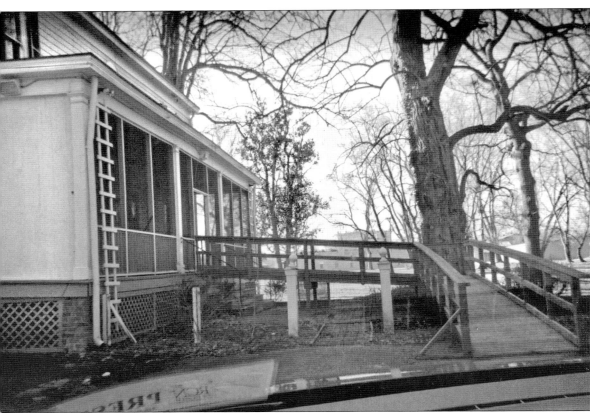

This close-up of Shirts Blanton's home in Ashland shows the ramp Blanton's wheelchair used to access the property. The porch from which Shirts watched the Auto-Train is on the opposite side of the house.

Six

The End of the Company
A Disappointing Conclusion
to a Worthy Idea

They say all good things must come to an end, but the end for the Auto-Train Corporation came all too soon. A rapid slide of accumulating setbacks did the corporation in.

On May 24, 1974, the corporation tried to expand its market area with a Midwest route from Louisville, Kentucky, to Sanford, Florida. A rocky relationship with the Louisville and Nashville prevented regular speedy and on-time service, and the condition of the L&N tracks was not conducive to a smooth luxury train operation.

Dr. Eugene Garfield, Auto-Train Corporation president, said it was a classic "If I knew then what I know now" situation—given hindsight, the Midwest portion would have used a different route or may not have been started at all.

More important to the demise of the corporation was the impact of back-to-back derailments. Garfield said, "We had two derailments. One was roadbed. One was broken wheels; cracked wheels that were manufactured by Bethlehem Steel. When we got that report I spent a lot of money to make sure that none of the other wheels were cracked."

He went on: "I didn't have control over the roadbed. I didn't have control over the wheels. I had control over what my passengers eat and how they sleep. I never saw in print and I never heard anybody say what I really felt. That was I never wanted to subject another one of my passengers to the potential for another derailment because of something I could not control. We certainly didn't stop it because there were no passengers.—I mean those trains were full forever, from the first day."

In spite of the brilliance of the idea and the excellence of its execution, deferred maintenance of the equipment, lack of funds, and credit capacity to replace damaged locomotives and passenger equipment ganged up to force the Auto-Train Corporation into bankruptcy in 1981. It was impossible even to cover the payroll in the final days of operation.

Horrendous publicity plagued the company in its final days. The two stations at Lorton and Sanford were closed and the train schedule suspended.

An inglorious auction months later accomplished the necessary sell-off of corporate assets. One correspondent who was in touch with the author during the writing of this book claims to have bought the "O Gauge Auto-Train set from Mr. Garfield's office."

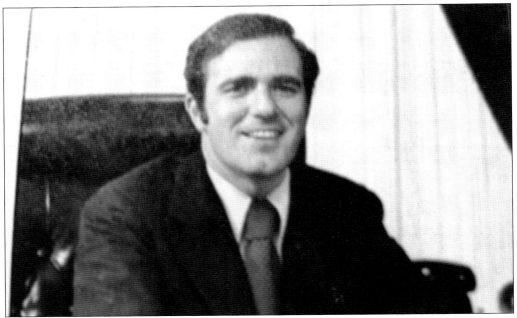

During the Auto-Train Corporation days, this portrait of the founder of the company appeared in an annual report. Dr. Eugene Garfield was still smiling in this picture, but the smiles turned to frowns when it became apparent that the finances of the company were beyond rescue and bankruptcy was the only alternative.

When the demise of the original Auto-Train Corporation was finalized in 1981, the obvious successor would be Amtrak. But nothing happened until two years later, when a three-day-a-week Auto Train began under the Amtrak banner. The schedule was expanded to daily a short time later.

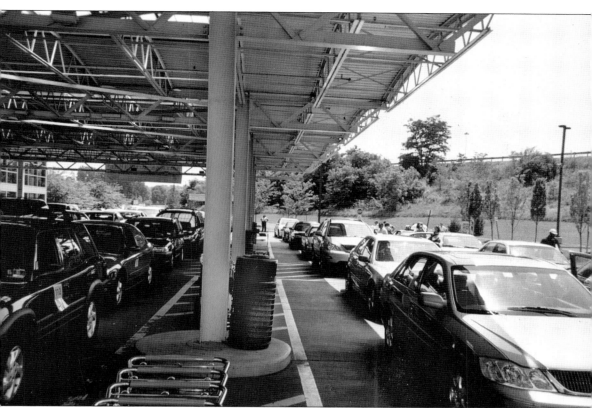

The Auto-Train experiment failed not because of lack of business. This picture shows a common sight—lines of cars and passengers waiting to get on the popular Auto-Train.

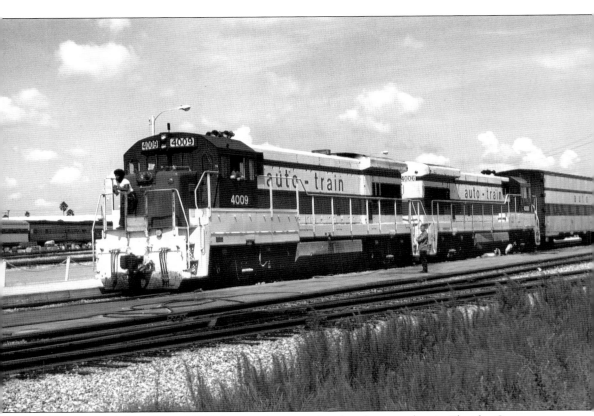

Two original Auto-Train U36B locomotives pose for the photographer in Florida. Green grass graces the foreground, and wispy white clouds float silently overhead. The locomotives are Nos. 4009 and 4006. (Courtesy of Bill Folsom.)

Seven

AMTRAK TO THE RESCUE
TODAY'S AUTO TRAIN
IS AN AMTRAK PREMIER ROUTE

"Amtrak" is made up of the words American and Track. Officially, Amtrak is known as the National Railroad Passenger Corporation.

In 1983, Graham Claytor became president of Amtrak. Claytor was a mentor to Dr. Eugene Garfield, and Garfield respected this senior statesman of railroading. The men met when Claytor was president of the Southern Railway, and Claytor had a lot of sympathy for what Garfield was attempting to accomplish. They kept in touch.

Graham Claytor, in his new Amtrak position, told Garfield, "I'm starting it up again because it was a brilliant service. And I'll keep everything you put in place." Soon after, Claytor passed away.

Garfield commented, "I think it was two years that the service was down and it was just as well. What they needed to do, what Graham did, was replace the wheels."

Knowing they had a tiger by the tail, Amtrak gingerly stepped back into the Auto Train business along the East Coast. Runs were scheduled starting October 31, 1983, at first only three times a week, until Amtrak could get the route established again in the marketplace. Seven-day-a-week service resumed in October 1984 and continues daily in both directions to this day. In 2008, Amtrak celebrated 25 years of their Auto Train.

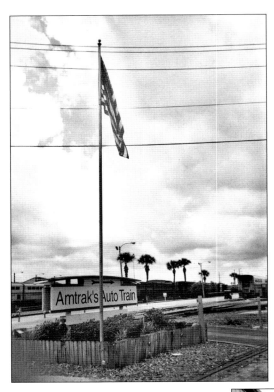

Patriotic and clearly Florida, this is what passengers see upon arrival at the Auto Train station in Sanford, Florida.

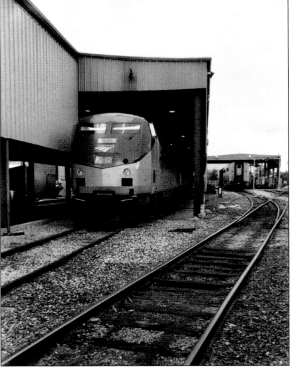

While Lorton, Virginia, yard crews make up today's consist of the southbound Auto Train, the huge GE Genesis locomotives idle peacefully under a shed on a siding. Southbound, the trains will carry the Amtrak designation No. 53. Northbound trains are No. 52.

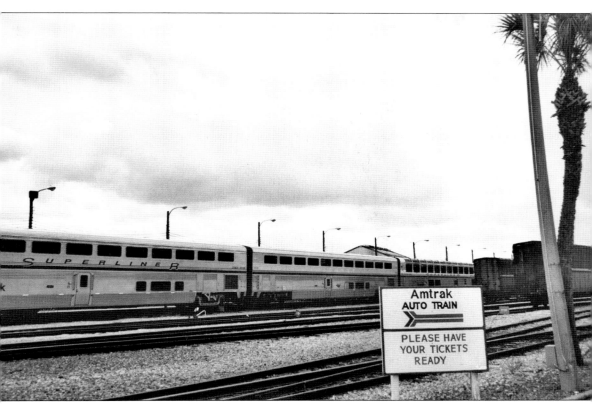

Amtrak Superliner equipment lines up along the driveway into the Auto Train terminal in Sanford, Florida, one summer afternoon in July 2004.

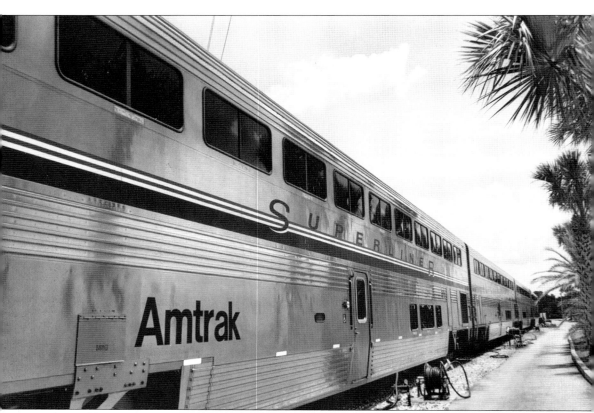

Amtrak's newest equipment on the Auto Train features Superliners providing full-dome convenience and modern appearance for the lucky passengers. Amtrak is the clever blending of the words "American" and "track." Officially, the railroad is called the National Railroad Passenger Corporation.

"Welcome to Amtrak's Auto Train" reads the overhead sign for passengers approaching the station at Sanford, Florida.

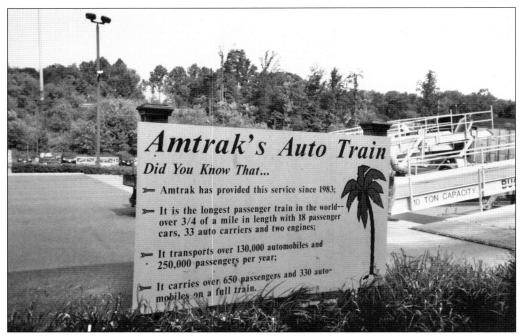

Amtrak's "Did You Know" sign along the platform in Sanford brags about the length of the Auto Train and its capacity. Vehicle loading ramps are visible in the background.

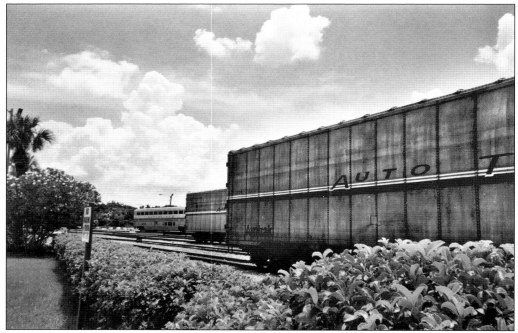

Two Auto Train car carriers may be seen on nearby sidings during loading. Yard engines will connect them as they make up the long passenger train before departure.

Auto Train by definition does not need a baggage car—everything remains with the vehicles in the car carriers. However, the author caught this unusual shot of a train car labeled "Amtrak Express Baggage" next to the string of taller Superliners before an Auto Train departure.

Passengers are loaded and ready to leave the terminal. Amtrak's Superliner coaches rest on the long, long station platform prior to departure.

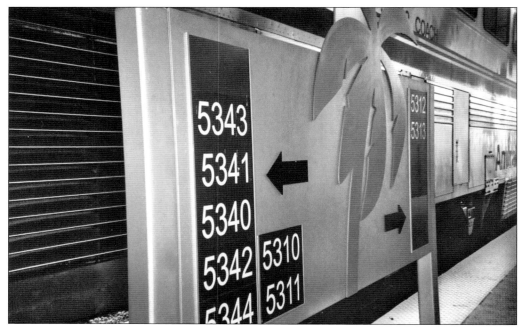

Amtrak station agents tell passengers the number of their coach or sleeper when they check in. Sign panels like this one line the platform so passengers know which way to turn to get to their assigned quarters.

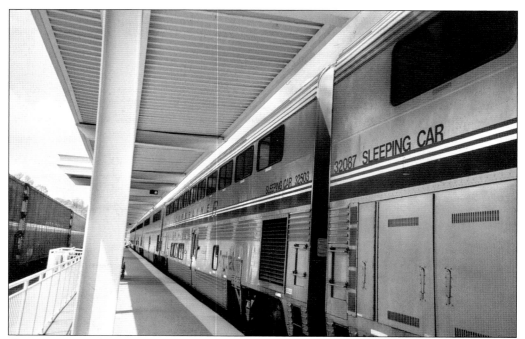

Sleeping cars make up this portion of the train. Passengers just walk on down and spot their car number. They find their assigned location to make their first step into the train and prepare for the overnight trip.

Amtrak's car carrier is in the foreground, and the loading ramps can be seen attached to the rear of the unit. Valets load the vehicles swiftly and carefully.

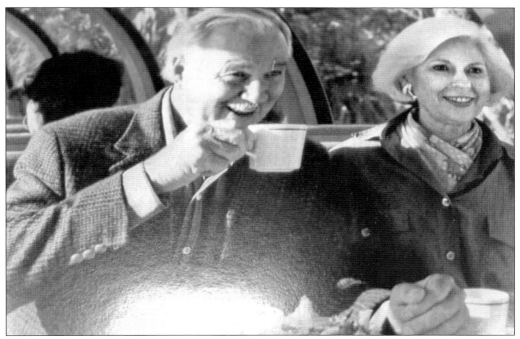

A pair of Auto Train passengers sip their coffee leisurely in the comfort of a dome lounge car. The couple apparently enjoys riding in luxury instead of pounding the interstate. (Courtesy of Amtrak.)

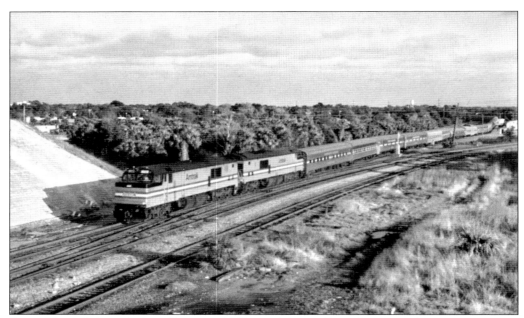

A northbound Amtrak Auto Train on CSX's ex–Atlantic Coast Line main line is seen passing through Sanford, Florida, 3 miles north of the Auto Train terminal in March 1994. (Photograph by Alex Mayes.)

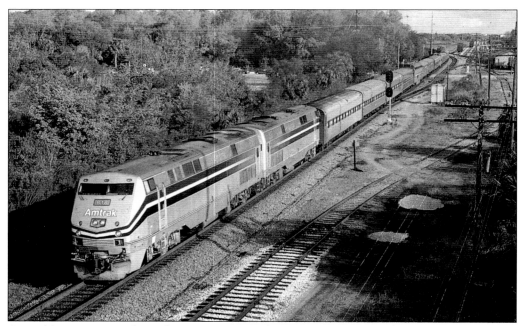

Amtrak's new auto and people mover restores this unique service in the Washington-Florida corridor. General Electric P30CHs 700 and 705 depart the southern terminal with a 40-car train on New Year's Eve, 1983. (Photograph by A. D. Saleker, DPM—Carl H. Sturner Company.)

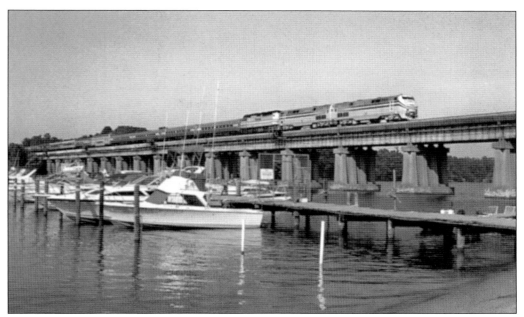

Amtrak's Auto Train, a daily service that provides transportation for people and their cars, makes the run between Lorton, Virginia, and Sanford, Florida. Two new General Electric Genesis locomotives lead the train over Aquilla Creek on CSX's former Richmond, Fredericksburg, and Potomac (RF&P) mainline near Stafford, Virginia. (Photograph by Alex Mayes.)

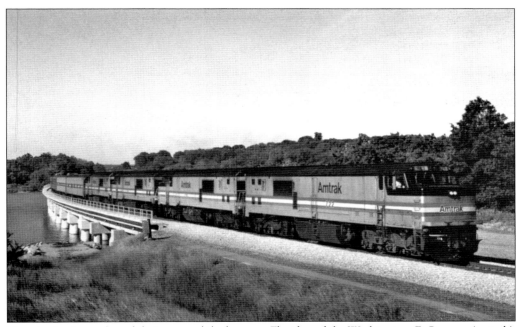

Carrying both people and their automobiles between Florida and the Washington, D.C., area, Amtrak's Auto Train passes over Quantico Creek at Possum Point, Virginia. Four GE P30CH locomotives power the 34-car train over the RF&P in June 1988. (Photograph by B. R. Henderson.)

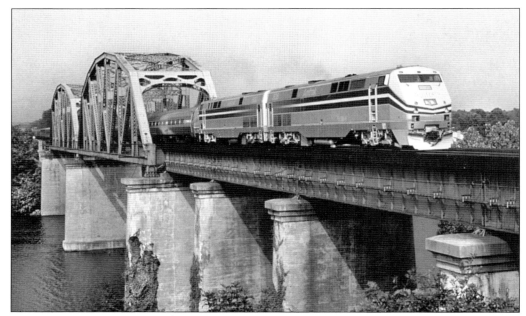

Twin GE AMD-103 Genesis locomotives—Nos. 808 and 800—lead the popular Auto Train southbound over the Occoquan River at Woodbridge, Virginia, on July 22, 1993. (Photograph by Alex Mayes.)

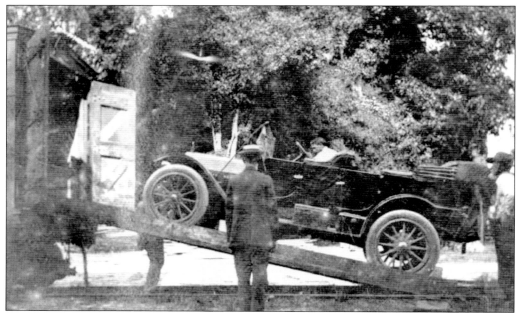

This postcard depicts a scene that is likely out of the history of today's Auto Train. The card carries the message, "Original Auto-Train De Leon Springs, Florida. These cars were being loaded onto a train for a trip to Buffalo, New York. 1912."

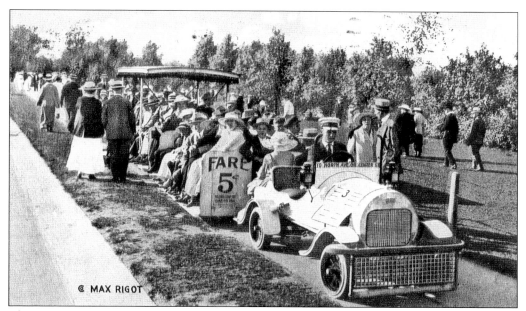

The auto train, a string of open cars pulled by a tractor and used to move visitors about the grounds of an exposition, was invented for, and first used at, the 1915 Panama-Pacific Exposition at San Francisco. Manufactured by the Fageol Brothers and their Fageol Auto Train, Inc., company in Oakland, California, they were labeled as "Fadgl Auto Trains" to approximate the actual sound of the oddly pronounced name. The trains were used in Chicago's Lincoln Park after the end of the fair.

An Amtrak brochure teases, "How to Make 18 Hours of This," and shows a highway with yellow center lines passing by.

One of the benefits of being a first-class sleeping car patron on Amtrak and Auto Train is a packet of writing materials in a burgundy folder clearly labeled "First Class."

The first-class passengers on the Amtrak Auto Train receive a small packet, including writing paper and a pen. Pictured is the heading on the writing paper.

Eight

HIGHBALLING A HYBRID
BY BOB JOHNSON IN *TRAINS* MAGAZINE

As a regular reader of *Trains* magazine for more than 50 years, this author has found tons of interesting articles and learned a great deal about the hobby of railroading. This publication brings current railroad news and pictures to rail fans each month.

In the November 1992 issue of *Trains*, writer Bob Johnson, out of Chicago, wrote an article about a trip on the Auto-Train. His sidebar about "Highballing a Hybrid" was right on target for readers of this Arcadia *Auto-Train* book. Kalmbach Publishing agreed to allow the reprint of the article here.

The reader's journey aboard the Auto-Train locomotive with Bob Johnson will make one appreciate what goes on at the head end while passengers are dining or sleeping.

Ride along in the Auto Train Locomotive

"FIFTY-THREE—you got 'em all on the mainline. Have a good trip. Over." Brakeman Maryanne Kimetz's cheerful voice crackles over the cab radio. The last of 19 passenger cars and 17 auto carriers has threaded the track switch at Lorton, Virginia.

Assistant engineer Bob Hayhurst and engineer Steve Armstrong take turns at the controls of F40PH diesel 396, switching seats at Richmond, Va., Rocky Mount, N.C., and Fayetteville N.C., as they guide Amtrak's southbound *Auto Train* 389 miles to Florence, S.C. Another operating crew takes over at Florence for the second half of the run to Sanford, Fla. Riding today as far as Richmond is Assistant Transportation Superintendent John Quigley.

"It takes a lot of talent to handle this train, because all of the weight is on the hind end," Quigley points out. His hand on the throttle, Hayhurst only now moves it out of the first position to Run 3. "There's a tendency for both passenger and freight engineers to get up to speed as soon as the last car is moving," says Armstrong from the left hand seat yelling above the increasing din. "We can't afford to do that."

Now the cab signal between the windshields and the high green on the mast outside along CSX's Richmond, Fredericksburg & Potomac Division tracks beckon. Hayhurst moves the throttle all the way to the left on a gentle upgrade. "It's a matter of how long you run in number 8," he shouts, referring to the maximum setting on the F40's throttle. The white speedometer needle inches up to 58–59 mph, but a mile ahead there's a speed restriction. With the throttle still open wide, Hayhurst moves the red train brake handle; hissing air escapes. He deftly taps the black engine brake lever down and there's a muffled burst. "Look, I've made an 8 pound application and nothing has happened. If this were a passenger train, you would immediately see response."

But *Auto Train* is a hybrid, so the brakes on the passenger equipment assigned to it are adjusted to apply and release gradually, like freight-car brakes. A planned cut-out of brakes on about half of the auto carriers makes the heavier rolling stock on the rear react even more slowly. Hayhurst reduces the throttle just as the application becomes apparent. Now, the train is at the proper speed for the Powells Creek bridge and curve on the other side. We pound across. With no walkway on the double-track structure, there seems to be nothing to keep the locomotive from vibrating off the bridge and into the pleasure boats below.

"You try to try to keep the train stretched at the top and bottom of hills," says Hayhurst, as the whine of the locomotives intensifies. He grabs the vertical horn handle above the throttle and eases into two longs, a short and a long for a grade crossing and kicks the automatic bell off. From across the cab, Armstrong explains further: "We try for a minimum of reduction while still working a bit of power so we don't have all that run-in and jerk-out. This hill here has a little bowl on top of it, a little dip. An engineer handling a freight train wouldn't be too concerned about the slack, but we have to be because our train is so heavy." Another bridge. Then a curve.

Because *Auto Train* engineers don't work other runs, they need only be concerned with variations between peak and off-peak consists, usually between 36 and 47 cars. Most are former Seaboard Coast Line "hogheads" who originated Amtrak's seniority list when *Auto Train* service began in 1983. They have honed their specialized skills ever since.

"We don't miss the P30's, not one bit!" Armstrong says of the General Electric P30CH units that were Auto Train's signature locomotives until General Motors–built F40s supplanted them in 1991. The three men digress into "can you top this" war stories of the engine-room fuel oil pools and stack fires that plagued the 1974 GE behemoths before their recent retirement.

A few miles farther, with the speedometer hovering at the 60-mph maximum (70 is allowed south of Richmond). The cab signal suddenly drops to a yellow-over-green indication. "Approach medium!" shouts Armstrong. But the man on the right already has moved the red brake handle and then the black, both gushing air. Hayhurst straightens and shifts in his chair, rests his right hand on the throttle, pauses, then moves it back to the right. Only now does the needle edge off the 60-mph mark.

The men in the cab know what lies ahead: a red over red absolute stop signal guarding the single-track concrete bridge over Quantico Creek. Amtrak train 80, the *Carolinian*, is stopped at the station on the other side of the bridge. The northbound train, not *Auto Train*, has the green. Hey, it hardly seems fair. He's only got five cars!

Back in the buffet cars, with plastic glasses neatly centered on the tables and the kitchen crew preparing to feed 307 passengers, a slight sloshing of wine in the carafes is the only hint that Hayhurst has reacted. Numerous seconds pass, then the train begins to slow as Hayhurst's hands dance between the handles. "Approach" booms Armstrong as the yellow signal at North Possum Point comes into view.

"Clear!" The cab signal flicks to green, the drama is past. But the engineer must now reverse the stopping process while keeping his train strung out. "You've got to know where the slack is in the train at all times," Hayhurst says as the headlight and bridge approach signal come into view.

A few minutes later the train sweeps right across the graceful structure. Then, there's a slight upgrade, another hill, and a curve. The smell of fresh clover wafts through the cab, coming from a field on the left in front of the white frame house where Confederate Gen. Stonewall Jackson is said to have died.

"BBBUUURRREEE!" screams the alerter, its cacophonous warning automatically sounding because Hayhurst hasn't touched the controls in 20 seconds. He routinely responds by mashing the reset button and the noise is silenced. It doesn't sound very often.

Another highway crossing looms as the afternoon sun's horizontal shafts stab across the double-track right-of-way. A white pick-up truck races from the east toward the lowered gate as the engineer make his last of four horn blasts. Hayhurst instinctively rests his hand on the red handle. But what good would it do? If the driver could only appreciate what engine crews must live with. But good judgment prevails and the truck driver stops just short of the gate.

A choppy voice crackles over the radio. "That's Becky [Tressler] on number 90," remarks Quigley, referring to the northbound *Palmetto*'s engineer. Her wave can be seen through the cab window of the F40 349 a few minutes after *Auto Train* crunches across the CSX diamond at Doswell, Va. Soon a baseball field appears near the tracks, with a Little League game in progress; the centerfielder looks over and Hayhurst gives a thumbs-up. The engineer has begun a gradual brake application for the 35-mph Ashland (Va.) speed restriction several miles back. Now the big train is overtaking bicyclists as it slips down the middle of Ashland's quiet main street in front of the manicured lawn of Randolph-Macon College.

Ahead lies Richmond, then Petersburg, the Carolinas, Jacksonville, and Sanford. Between now and the scheduled 9 a.m. arrival, *Auto Train* engineers are expected to gingerly manipulate this complex mass of rolling stock over the road at the maximum allowable speed for each section of track. They must know it all—curves, speed restrictions, grades (up and down), signals—better than a palm reader who studies the lines in his own hand. The unexpected may lurk around the next bend.

As Bob Hayhurst says, "It's easy to get into trouble if you don't know what you are doing." Because the engineers who diligently ply their trade are craftsmen, the passengers who otherwise would be battling speeding double-bottom semi-trucks on nearby I-95 can enjoy the ride.

—Bob Johnson
© 2009 *Trains* magazine.
Reprinted with permission of
Kalmbach Publishing Company.
All rights reserved.

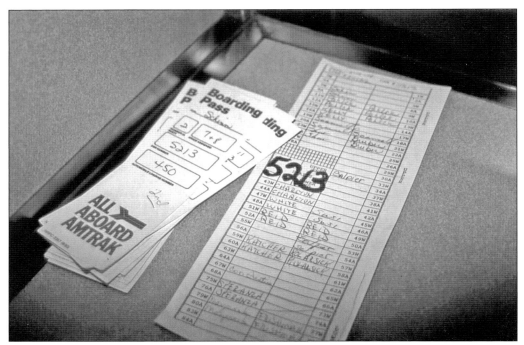

As with everything else in life, there is paperwork to go with one's car assignment on a passenger train. When Bob Johnson picked up his boarding pass and sleeper assignment, his paperwork looked like this. (Photograph by Bob Johnson.)

With the advent of Amtrak as the operator of the Auto Train service, new engines replaced the U36Bs of the original corporation. This GE F-40 Genesis was one of the new fleet of locomotives that powered the new version of the super ferry service.

Nine

FINAL THOUGHTS AND PHOTO GALLERY
AUTO TRAIN REMAINS A NATIONAL TREASURE

The Auto Train route of Amtrak is a source of pride for the nation. The country has a superior passenger railroad that rivals many in the rest of the world.

In this final section of the book, the reader will find various items from the author's collection of Auto Train memorabilia and photographs.

What a pleasure it was to work on this collection of pictures about the beautiful and unique Auto-Train. Hopefully each reader has found something in this book worth reading, sharing, or saving.

Some people expressed disappointment that the book was not full of negative stories about the original owners of the corporation, management decisions about expansion, and the several derailments that put the ultimate financial pressure on the under-capitalized company. Others remarked that the text chapters were so short, compared with the quantity of pictures.

Actually, this series of books (Image of Rail) published by Arcadia Publishing is meant to be mostly "picture books." These are heavy on photographs and light on stories. The mix seen here fits the Arcadia mold but precludes wordy explanations of less interesting topics.

Passengers who rode the Auto-Train in the early tenure consistently spoke highly about their trip—they loved the experience, the staff, the food, and the entertainment.

Concurrently, the staff loved the passengers. Auto-Train staff members were like a family, and they treated customers with that same loving attitude.

If fate had dealt the original corporation a better hand, many of the financial problems might have been overcome and Auto-Train Corporation, not Amtrak, would be running the Virginia-to-Florida ferry service today. All the factors for success were present. There was a market for the service. The public accepted it. The trip was affordable and was a pleasant experience.

Conversely, many of the factors for a business disaster also were present. Attempting to expand too quickly is a big one. Operating on a shoestring with inadequate reserves is another. Expensive derailments damaged the limited equipment—replacing engines and rolling stock was not affordable.

Auto-Train, now a national treasure, was a noble experiment and remains the shining jewel in today's Amtrak fleet, almost a decade into the new century and after more than 25 years' experience. Possibly the original Auto-Train will be the prototype for similar passenger trains in other parts of our nation as energy needs force Americans to revisit how they travel. Wouldn't Dr. Garfield love that.

These two brochures and the one on the next page indicate how Amtrak separates the Auto Train from the rest of the fleet and promotes its features.

"Take your car along for the ride" is the them of this Amtrak brochure.

AMTRAK'S NEW
SUPERLINER
EXPERIENCE

On a Superliner train you'll see sights you couldn't see from 33,000 feet up. You'll meet people you'd never get the chance to meet from behind the wheel of your car. You'll pass areas you could only get to with a backpack and sturdy mule. And for a change, getting where you're going will be *part* of the fun, not just a way to get to the fun.

If you haven't been on a Superliner lately, you're in for a very pleasant surprise. Today's trains are comfortable, quiet, modern and fully equipped for your convenience. On board you'll have everything you need to relax in style. And all along the way, you'll have big windows to look out of, and interesting people to talk to.

When you step on board one of Amtrak's Superliner trains, you not only get a great travel experience, but all this too:

• **Movies and videos**. . . including selections for children and travelogues. On most trains, we show current full length motion pictures.

• **Hospitality Hour**. . . featuring complimentary snacks and specialty drinks at special prices in the Sightseer Lounge.

• **Games**. . . including prizes!

• **Taped Music**. . . for your personal enjoyment in the lounge, diner and all private sleeping accommodations.

• **Complimentary Route Guide**. . . that describes scenic and historical sights along the way to make your Amtrak adventure more informative and enjoyable.

Amtrak's Superliners. Discover the magic.

When Amtrak passenger equipment evolved to the new Superliners, this brochure spelled out the benefits of riding trains featuring the new cars.

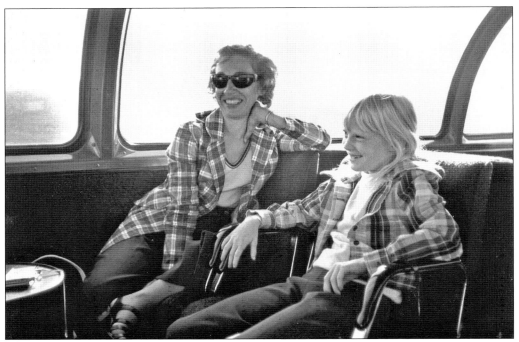

Is there any doubt that these Auto Train passengers appreciate their ride on the upper level of a dome car in place of a long, tedious ride down Interstate 95? The author's wife, Suzanne, and daughter, Linda, relaxed in the earliest years of the original Auto-Train Corporation operation.

The Auto-Train gift shops were full of souvenirs. This patch made the owner feel like part of the crew when added to a cap or jacket.

Auto-Train souvenirs filled the railroad gift boutiques. Key chains, match packets, and these Auto-Train playing cards were scooped up by passengers as remembrances of their trip.

They would not be as popular today in a strict non-smoking environment, but these matches from the original Auto-Train are preserved in the author's collection of Auto-Train memorabilia.

"auto-train™" word game

To find "auto-train™" Words in this puzzle, look at the list at the bottom of the page. Hunt the words in the di gram. As you locate a word, circle it and cross it off the word list. All words are always found in a straight lii either backward, up, down or diagonally. No letters were skipped. You will not use up all the letters in the diagram. Have fun!

by W. F

```
A U T O T R A I N C E L L I V S I U O
I H E D C D N O T G N I H S A W F C N
N O R T H C A R O L I N A J A S H O O
I S M E G N U O L T H G I L R A T S R
G T I N T E F F U B A K T M R N P Q T
R E N G I N E R G R P D S L A F T V H
I S A I W B C E F X I Y E L I O C M B
V S L N Z D F I V S R S B H G R Y I O
S G F E H J E D N I T S K L R D P D U
M E N E P L E E H O T Q R O O S R N N
N C I R D L Y A N R T O G L E S E I D
T O W V A W N V I E X N M T G Y S G N
A A T N O N Z H A H I U U O B C S H U
D C D R A M S P R B C T D O C E F T O
I H L V O S A G T H J S K T M O L S B
R D A N I L O R A C H T U O S Y L N H
O S U W M R I C H M O N D B M L K A T
L F E L L I V N O S K C A J N I C C U
F L O R E N C E O P P O T O M A C K O
R E P E E L S Q R E I R R A C R A C S
```

"auto-train™"	Diesel	Georgia	Midnight Snack	Richmond	Tie
Bingo	Dome	Hostess	Movies	Rocky Mount	Toot
Buffet	Engine	ICC	Northbound	Sanford	Train
Busch	Engineer	Jacksonville	North Carolina	Savannah	Trip
Car Carrier	Florence	Lemon Tree	Nuts	Sleeper	Virginia
Charleston	Florida	Lewis Shirts Blanton	Palm	Southbound	Walt Disney V
Coach	Fun	Locomotive	Potomac	South Carolina	Washington, I
Cypress	Garfield	Lorton	Purple Plum	Starlight Lounge	
Deland	GE	Louisville	Rail	Terminal	

An "Auto-Train word game" created by the author in 1977 was featured in the *Auto-Train Magazine* presented to passengers riding the train. This version might be a little hard to read, but someone with strong reading glasses might try to find the words.

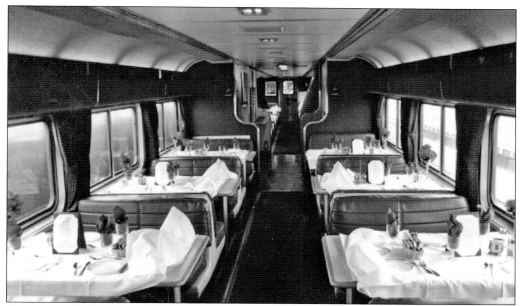

"Dinner in the Diner / Nothin' could be finer / Than to have your ham and eggs in Carolina," goes the song. Inaccurate geography notwithstanding, this shot of the Auto-Train diner was taken on the southbound trip near Jacksonville, Florida—tablecloths, napkins, flowers, and all the comforts of a plush restaurant. At breakfast, passengers from the North welcome the lush greenery of the South and enjoy palm trees everywhere.

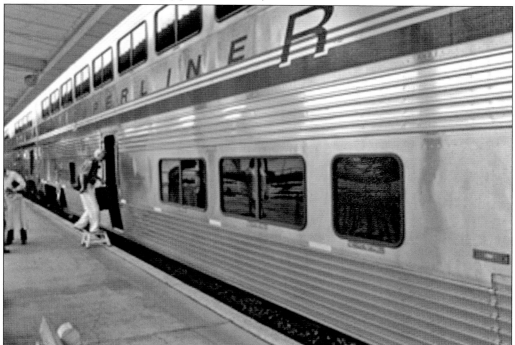

Passengers board the Superliner coach at Lorton, Virginia, in preparation for the overnight trip to Florida. Boarding is just the beginning of the fantastic Auto Train experience.

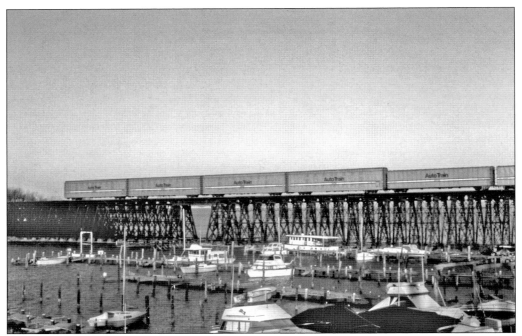

Most of the ¾-mile-long Auto Train has passed over the bridge on the Powels Creek in Virginia when this picture was taken. All that remains on the bridge is the final six car carriers. (Photograph by Bob Johnson.)

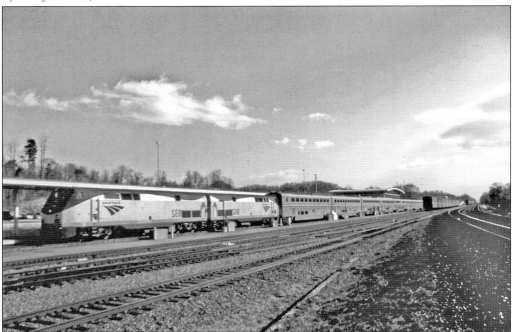

Once those big GE diesel locomotives are in place at the head end of the Auto Train, the trip is about to begin. That is the case here at the Lorton station just before the start of the southbound trip to Florida in February 1984. (Photograph by Bob Johnson.)

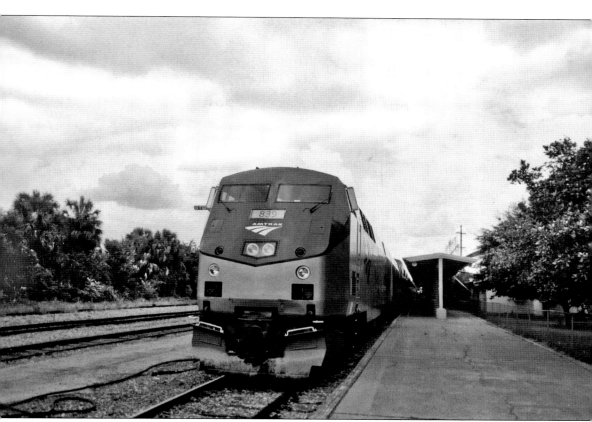

The engines are ready to roll, standing along the station platform at Lorton, Virginia, as Auto Train passengers await the departure of Auto Train for the overnight run to Sanford, Florida.

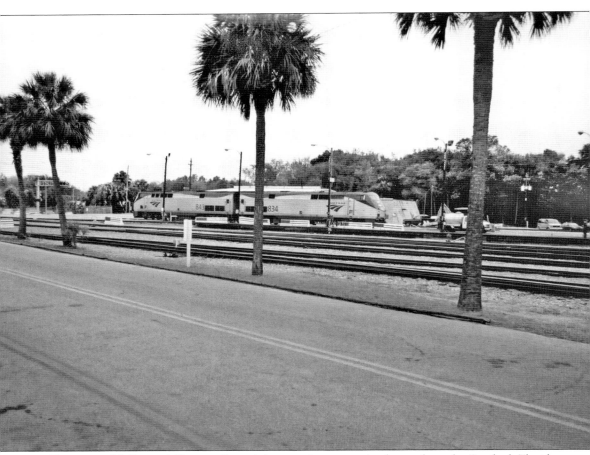

Two powerful General Electric Genesis locomotives pause in the yards at the Sanford, Florida, station before they join the consist of coaches, diners, and sleepers of the Amtrak Auto Train headed north to Virginia.

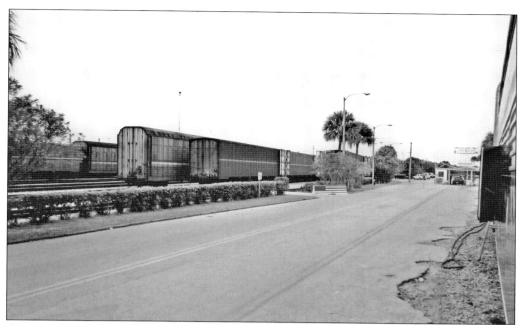

Car carriers were difficult to find when Auto-Train started running between Virginia and Florida. The early carriers came from Canada and held eight vehicles on two levels. Around 1976, the trilevel carriers were added, and newer trilevels operate on this Amtrak route today. Here in the Sanford yards, two strings of carriers await placement for loading today's northbound train.

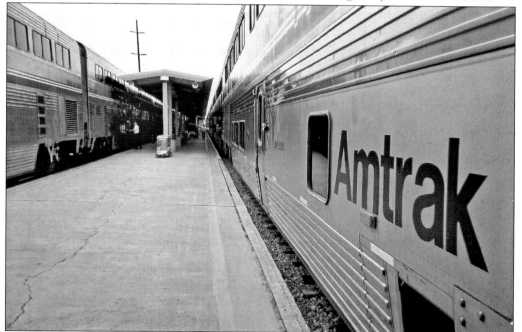

Amtrak saved the Auto Train operation in 1983, resuming the car and passenger ferry service started by the original Auto-Train Corporation. Here two strings of Superliner coaches border the platform before departure.

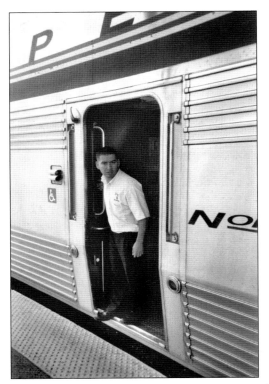

At Lorton, Virginia, before the Auto Train departed for Florida, a sleeper attendant identified himself only as "Jose." Here he checks the platform one more time for passengers or baggage that should be on board. Service personnel on the Auto Train take pride in attending to the needs of their passengers and protecting their belongings.

Amtrak Auto Train passenger David Ely peers from the door of the North Carolina Superliner sleeper, passing the time before the train pulls from the station and onto the main line.

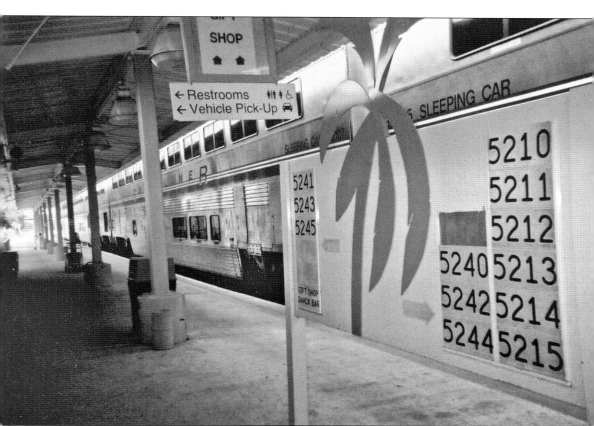

When travelers see this sign on the station platform in Sanford, Florida, they know they are very near to the start of another Auto Train adventure. If they just follow the arrows to their quarters for the trip, it won't be long before their overnight trip will be under way.

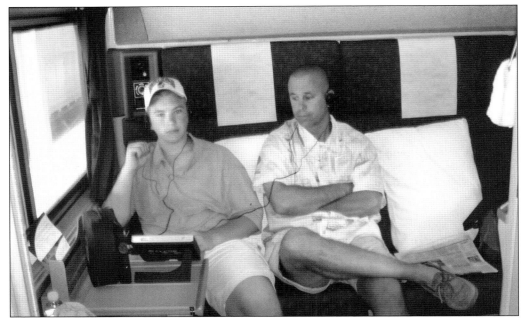

One way to keep occupied during the overnight trip to or from Florida on the Auto Train is to rent a video player and movie from Amtrak at the station. Here Charles Wielder Jr. and his son Michael, from St. Michaels, Maryland, pass the time with the video player. Each of them is wearing an earphone while enjoying the film in their Superliner sleeping car compartment.

An Auto Train switcher locomotive cruises past a string of passenger cars while making up the train before leaving on the overnight luxury trip along the southeast coast. Car carriers must be strung together before the passenger coaches and sleepers are attached. Then the over-the-road diesels connect last, and the trip is about to get under way.

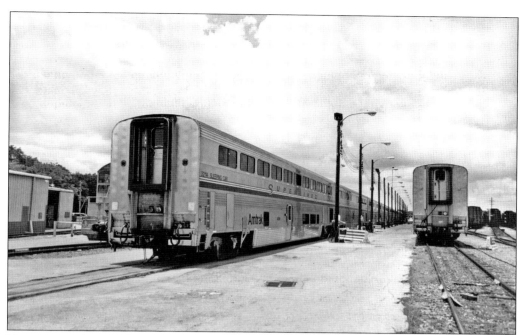

Not every car is pressed into service every day on Auto Train. For example, here are strings of cars parked on sidings in the Sanford, Florida, Amtrak yards. These are undergoing various types of service and maintenance and will be back in the train consist shortly—maybe even tomorrow.

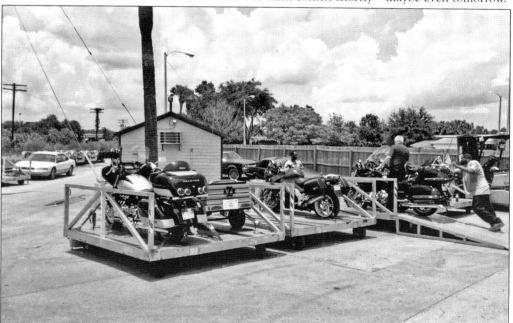

Amtrak is particular about what type and size of vehicles it permits on the Auto Train. This picture documents the fact that transportation items other than automobiles are carried, too. These pallets carry motorcycles and small trailers and eventually are loaded inside the car carriers for the train ride.

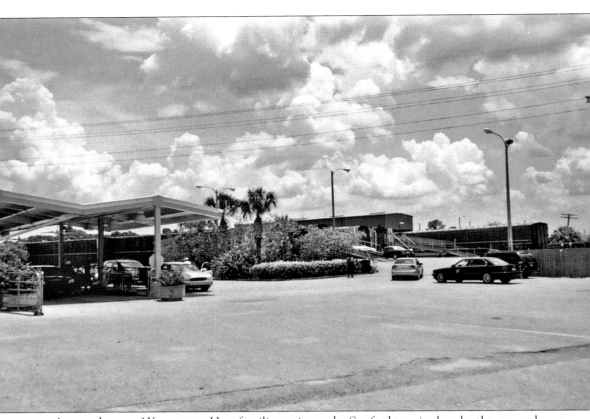

Are we there yet? Yes, we are. Here families arrive at the Sanford terminal under the covered area to remove essential items from their cars. In the background, car carriers are accepting vehicles on the loading ramps.

This scene shows an Amtrak employee videotaping the incoming passenger car after the family drops it off and heads for the station lobby. This car will not be on the news tonight, but the video will document the condition of the car upon arrival at the Amtrak station. If there is a new scratch in your car after the trip, Amtrak will be able to prove they did not put it there.

Here is a very familiar sight to travelers leaving the Amtrak station parking lot in Sanford. Those who are headed to I-95 or I-4 just follow the arrows to head in the right direction.

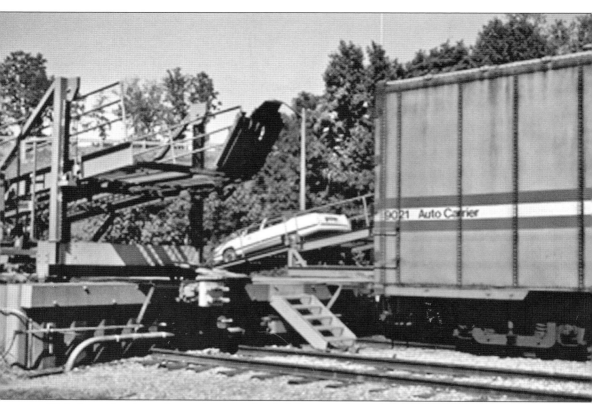

This is a side view of a car being unloaded from an Amtrak car carrier. Passengers wait at the station for their vehicles to be driven under the covered shed to resume their vacation or business travels.

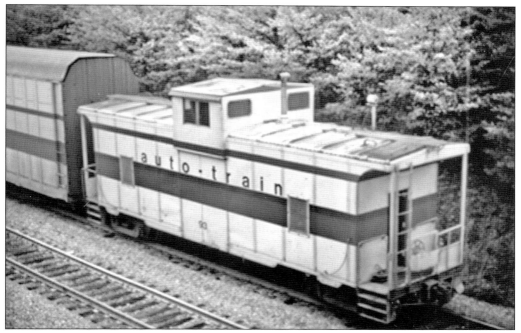

Some Auto-Trains carried a traditional freight caboose behind the car carriers. In this picture, at Doswell, Virginia, the car carriers rode behind the passenger cars; then came the caboose. (Photograph by Andre Menaro.)

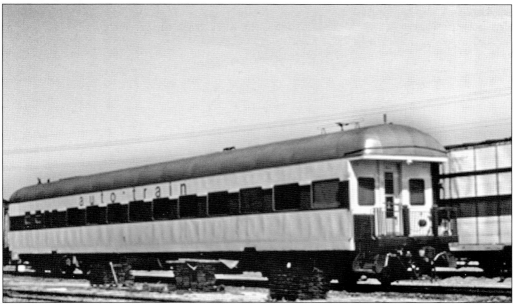

Some Auto-Trains sported a luxury observation car at the rear—mostly carrying corporate or other railroad officials on the daily Virginia-Florida run. For a time, the old Auto-Train Corporation sold places in this car to passengers as an extra-charge luxury accommodation. On loan from the Southern, it was repainted in classic Auto-Train colors. (From the collection of Brent MacGregor.)

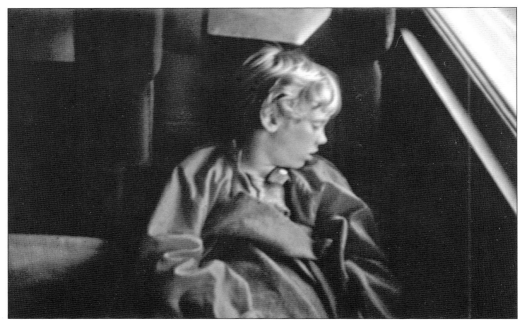

One of the benefits of Auto-Train travel is the comfort and roominess passengers experience. Unlike trying to nap in a crowded automobile speeding down the interstate, the author's son Scott dozes peacefully during his Auto-Train trip wrapped in a comfy purple Auto-Train blanket. An alert coach hostess spotted Scott napping and added the cover.

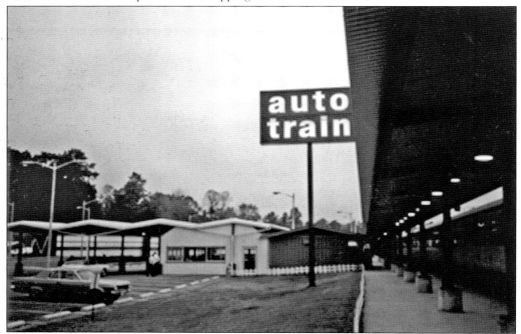

There is no doubt where one is when entering the driveway of the Auto-Train terminal. The strong identification hovering above the ground facilities gives one a sense of security that he or she has found the station, and the rest should be easy.

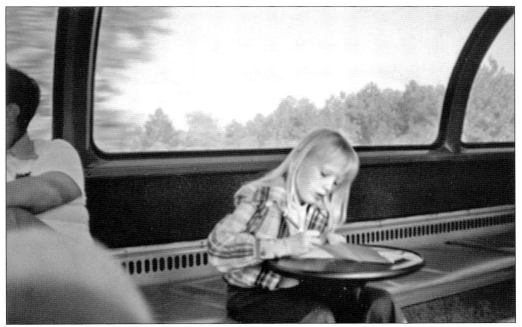

The author's daughter, Linda Ely, passes the time writing postcards to her friends while cruising along in the upper level of a full-dome coach. Linda's family was heading for Disney World in the very earliest years of the original Auto-Train.

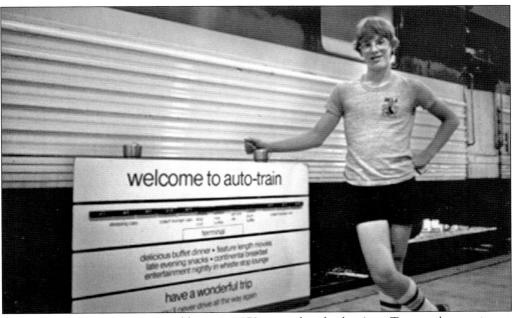

welcome to auto-train

terminal

delicous buffet dinner • feature length movies
late evening snacks • continental breakfast
entertainment nightly in whole stop lounge

have a wonderful trip

David Ely, the author's 12-year-old son in 1972, poses beside the Auto-Train welcome sign at the Lorton station before departure. As an adult, David still rides the Amtrak Auto Train when he can.

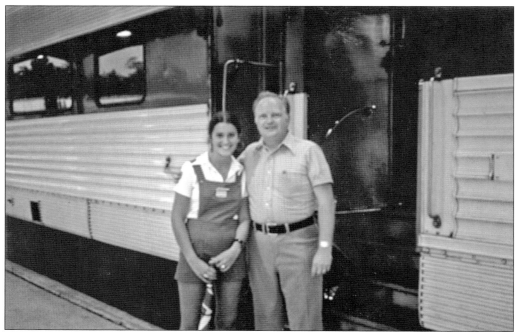

The author hugs an unidentified Auto-Train hostess while awaiting departure from Lorton in 1972. Company employees were personable and ready to pose for a picture with a customer.

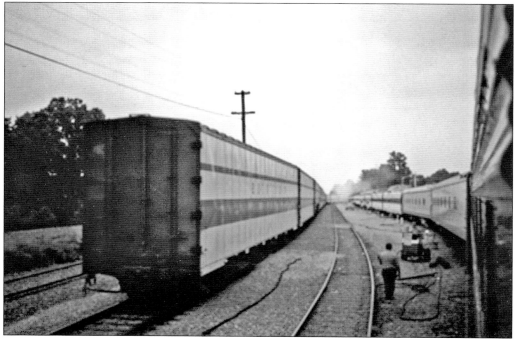

This string of car carriers is being maneuvered onto the track to join the rest of the Auto Train consist. The author shot this activity from the train just before departure.

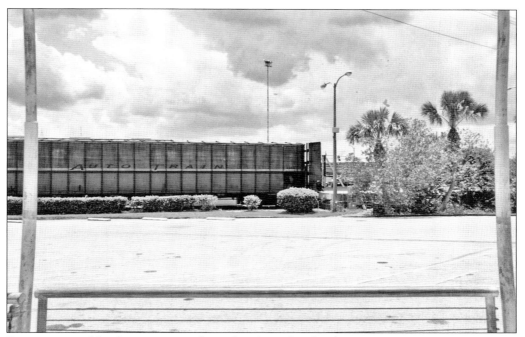

Doors open and loading ramps in place, this Amtrak trilevel car carrier prepares to accept its cargo prior to an Auto Train trip to Virginia.

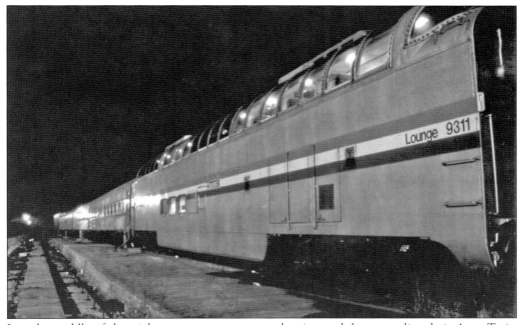

It is the middle of the night; most passengers are sleeping and do not realize their Auto Train has stopped for servicing and crew change in Florence, South Carolina. The lights are still on in lounge car No. 9311 while Amtrak workers hustle to get the train rolling quickly. (Photograph by Bob Johnson.)

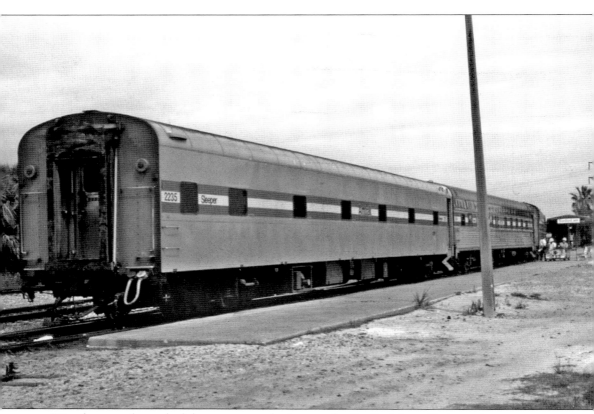

Way down at the end of the passenger platform at the Sanford Auto Train station, passengers load onto two sleepers. The nearest one is No. 2335. Soon the big diesel-electric locomotives will connect to the train for the start of the 985-mile overnight trip to Virginia. (Photograph by Bob Johnson.)

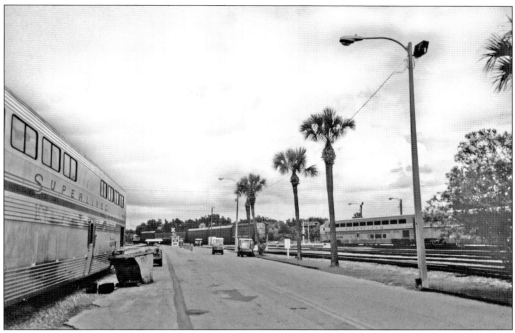

Passenger train cars appear to the right and to the left as one drives along the Sanford driveway to the passenger station. The Superliners look inviting.

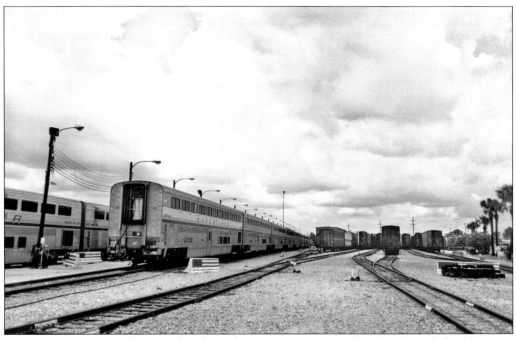

The Amtrak station in Sanford, Florida, is a beehive of activity in these last hours before the Auto Train departure on a July afternoon in 2004. The car carriers are loading on the spur to the right, and the Superliner coaches and sleepers await their passengers along the platforms on the left.

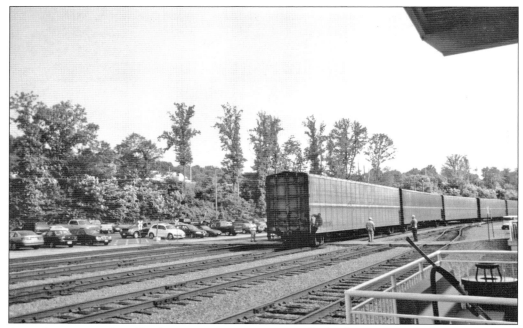

Amtrak crews gently guide the car carriers into position for loading next to the Lorton terminal as activity for today's Auto Train gets under way. This first cut will be followed by six more, and loading ramps will be placed to allow the vehicles to enter the carriers.

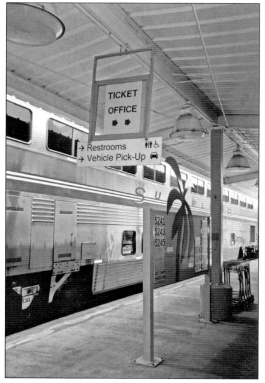

Just outside the Sanford ticket office and passenger lobby, the Auto Train Superliner coaches and sleepers await the coming burst of activity as Amtrak gets its signature train ready for another overnight trip to Virginia.

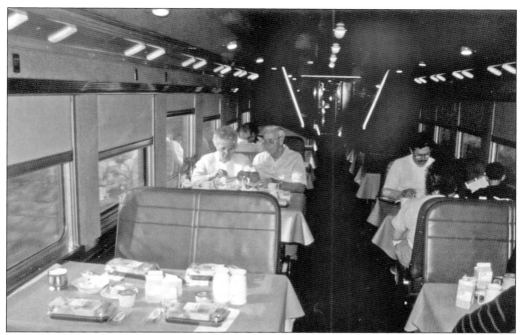

Many Auto Train passengers say the mealtime experience in the diner is the highlight of the overnight trip. It is truly enjoyable to be served a meal while the countryside passes by outside the window as the train rocks gently along. (Photograph by Bob Johnson.)

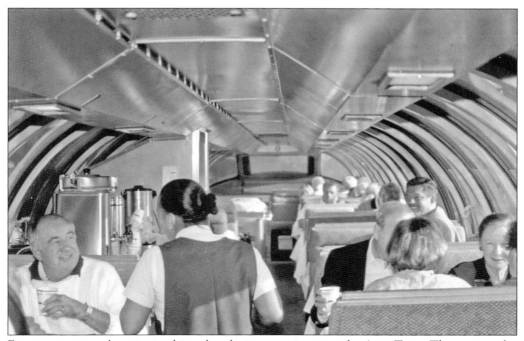

Everyone seems to be enjoying his or her dining experience on the Auto Train. There are smiles on all the faces as the attendant chats with a diner. (Photograph by Bob Johnson.)

For those who love seafood, this baked salmon dinner being prepared in the Amtrak first-class kitchen by Lynn Morrow will be a treat to be remembered. (Photograph by Bob Johnson.)

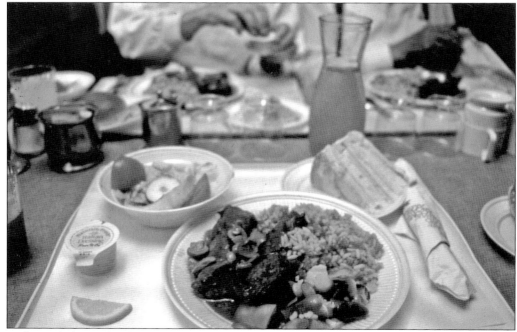

A short rib dinner has been served in the Auto Train diner. It looks like a hearty meal including a salad and dessert. (Photograph by Bob Johnson.)

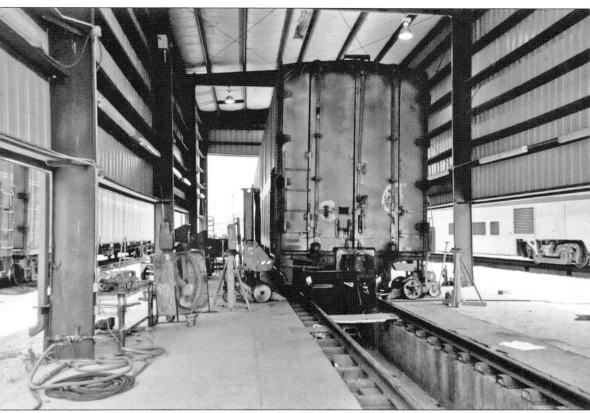

Auto Train riders will not get to see this area around the Sanford station unless the security guy is napping—it is off-limits to the public. An Auto Train coach is receiving a set of new trucks as part of the maintenance program.

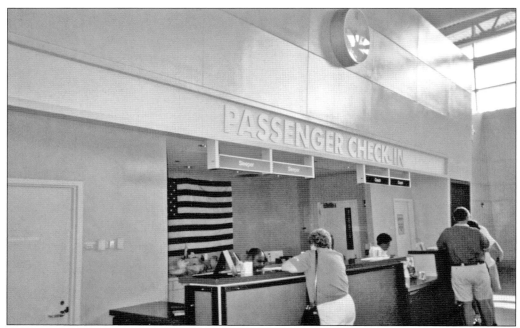

Passenger Check-In confirms passengers' coach location or sleeping arrangements. Here at the counter in the Lorton Amtrak terminal, passengers also choose their dinner sitting.

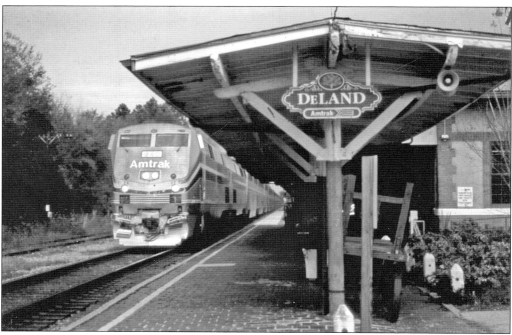

When one is heading south on the Auto Train, passing the Deland, Florida, Amtrak station means the train is almost at Sanford, the destination. This shot of the train rumbling through is from February 1998. (Photograph by Bob Johnson.)

Auto-Train passengers in the days of the original corporation were entertained during part of each trip with a bingo game in a lounge car. Here an attendant is transformed into the bingo caller, who keeps the game going while the passengers compete for prizes.

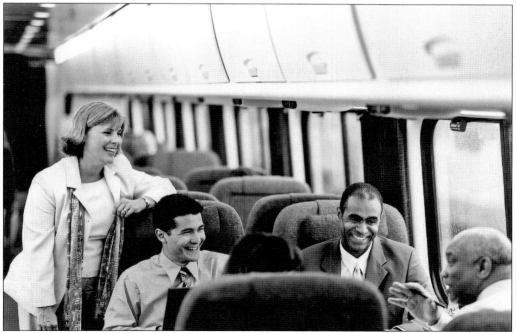

Life in the Auto Train coaches is a real social event. Passengers can chat, sleep, or enjoy the passing scenery. (Courtesy of Amtrak.)

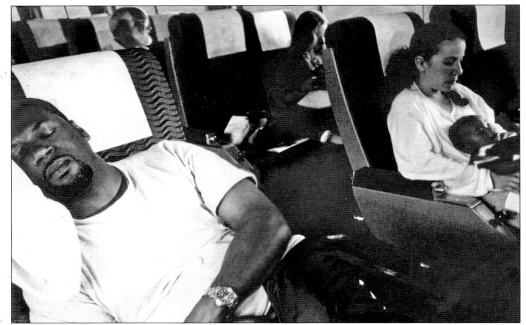

Passengers find a variety of ways to enjoy their Auto Train trip. This rider is spending part of his ride napping. (Courtesy of Amtrak.)

Auto train passengers enjoy a pleasantly different view of passing scenery than they would experience driving the interstate. (Courtesy of Amtrak.)

Amtrak coach passengers on Auto Train find ways to occupy their time. Some get in extra reading (above), while others chat with friends (below). (Both courtesy of Amtrak.)

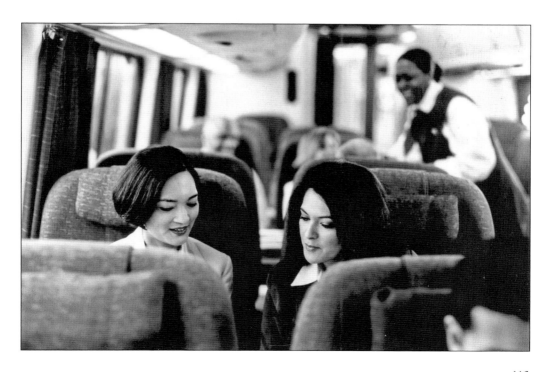

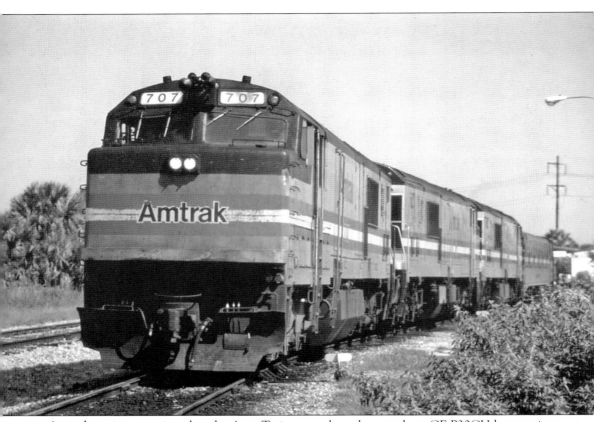

Amtrak engineers assigned to the Auto Train were pleased to see these GE P30CH locomotives phased out when a new series arrived.

The Auto-Train Corporation had an order of General Electric locomotives almost ready for delivery when the company closed down in 1981. Conrail engine No. 2974 was one of those built for Auto-Train that needed a new home and found service elsewhere. (Photograph by Marc Grinter.)

Do you think he will put the top up before turning over his convertible to the Auto Train valets? This pair of passengers is receiving directions to the terminal before embarking on their railroad trip adventure. (Courtesy of Amtrak.)

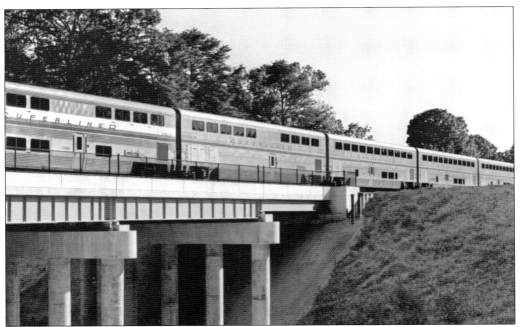

These Amtrak Superliner coaches and sleepers make a majestic sight as home to Auto Train passengers on the overnight run along the East Coast of the United States every night.

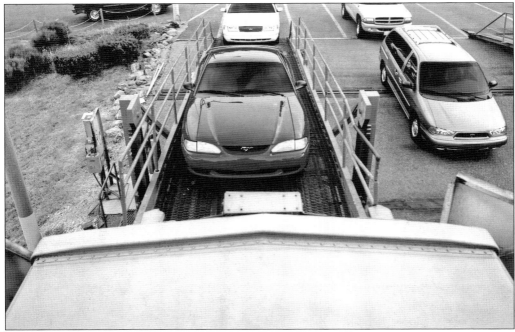

Shown is a unique overhead view of the vehicle loading process at the Auto Train terminal. Cars are driven up a ramp and into the car carriers by experienced valets.

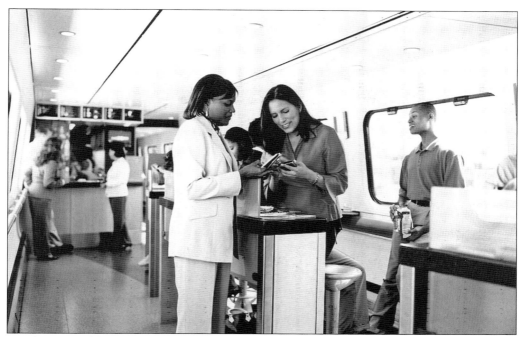

Snacks are readily available for passengers in the lounge cars. An attendant helps a passenger make a choice as the Auto Train rolls along. (Courtesy of Amtrak.)

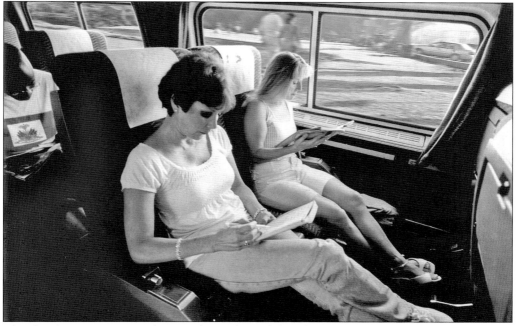

This family enjoys passing the time by reading while riding in the comfortable coach seats on Auto Train. (Courtesy of Amtrak.)

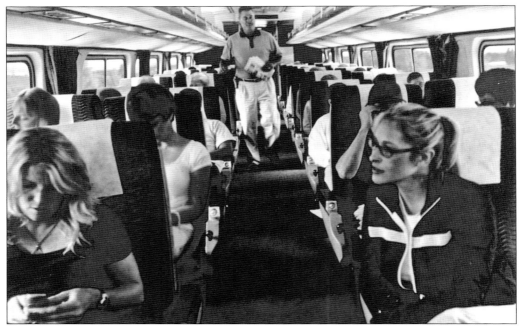

Pictured is a typical Auto Train passenger coach scene—passengers chatting or just passing through. (Courtesy of Amtrak.)

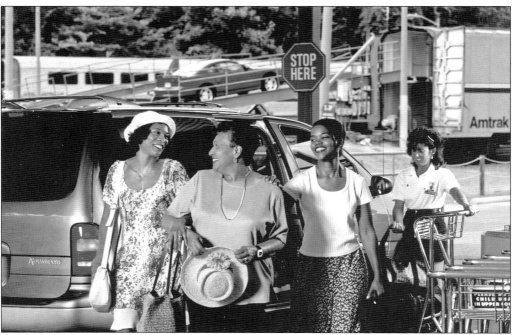

Lots of activity occurs around the Auto Train terminals in the hours before train time. This group leaves their car in the hands of the Auto Train valet while heading into the station lobby. Car carriers are being loaded in the background.

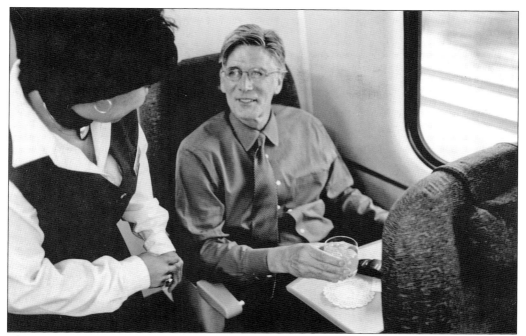

This Auto Train passenger chats with an Amtrak attendant while pausing for a beverage in the lounge. He is enjoying the trip without having to drive almost 1,000 miles down the interstate to get to his destination.

A ride on the Auto Train is usually a family activity. Here two generations share the passing view from the window of a sleeping car. There are no passing tractor-trailers to worry about on this trip. (Courtesy of Amtrak.)

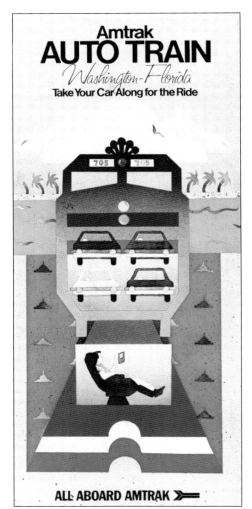

This Amtrak brochure dates from 1983, when Auto Train was new to Amtrak. The message is, "Take Your Car Along for the Ride."

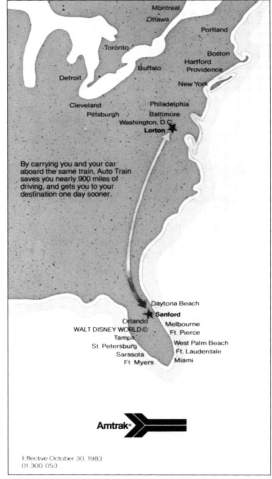

This panel of a 1983 Amtrak brochure locates the Auto Train route from Virginia to Florida.

An Amtrak locomotive pulls into the sunshine from the protective cover of a shed as train time nears. The locomotive will be attached to the Auto Train for the overnight trip up the East Coast.

Is it a television or a game or maybe a movie? Whatever it is, this family on the Auto Train is doing whatever they care to in a luxury coach environment. (Courtesy of Amtrak.)

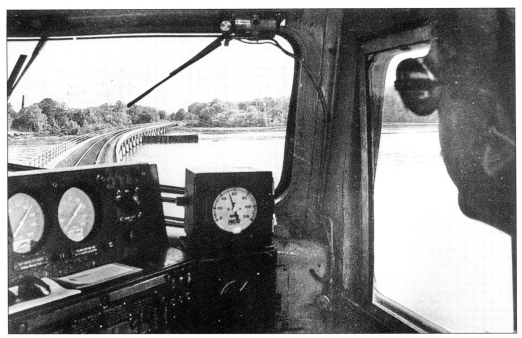

The Auto Train engine crew has this view of the Quantico Creek bridge during the early stages of a southbound trip. (Photograph by Bob Johnson.)

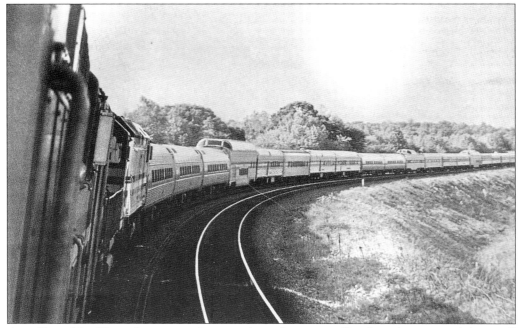

Auto Train No. 53 can be seen in this view from the engine. Coaches, sleepers, and diners all precede the car carriers, which are out of view.

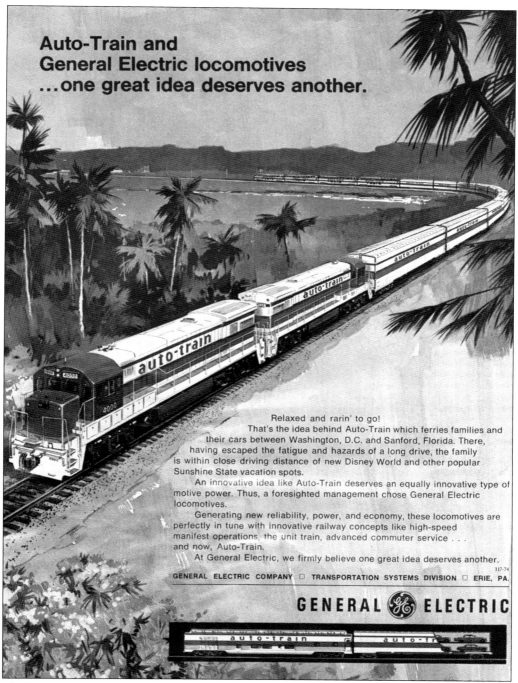

Auto-Train and General Electric locomotives ...one great idea deserves another.

Relaxed and rarin' to go!

That's the idea behind Auto-Train which ferries families and their cars between Washington, D.C. and Sanford, Florida. There, having escaped the fatigue and hazards of a long drive, the family is within close driving distance of new Disney World and other popular Sunshine State vacation spots.

An innovative idea like Auto-Train deserves an equally innovative type of motive power. Thus, a foresighted management chose General Electric locomotives.

Generating new reliability, power, and economy, these locomotives are perfectly in tune with innovative railway concepts like high-speed manifest operations, the unit train, advanced commuter service . . . and now, Auto-Train.

At General Electric, we firmly believe one great idea deserves another.

117-74

GENERAL ELECTRIC COMPANY □ TRANSPORTATION SYSTEMS DIVISION □ ERIE, PA.

GENERAL ⊕ ELECTRIC

This Auto-Train advertisement was produced for the original Auto-Train Corporation to develop business going back to September 1972.

Amtrak published this card as a promotional piece for their Auto Train. The graphic presentation clearly tells the story of this mode of transportation.

Passengers are provided with information regarding how to deal with emergencies should the unexpected occur. This booklet of instructions came from an Amtrak sleeping car.

You're helping America save 11,000,000 gallons of fuel.

This message speaks for itself. An amazing amount of fuel is saved when automobiles are off the highways and on the Auto-Train car carriers. The statement appears in an advertisement by General Electric, which manufactured the original diesel-electric locomotives for the Auto-Train.

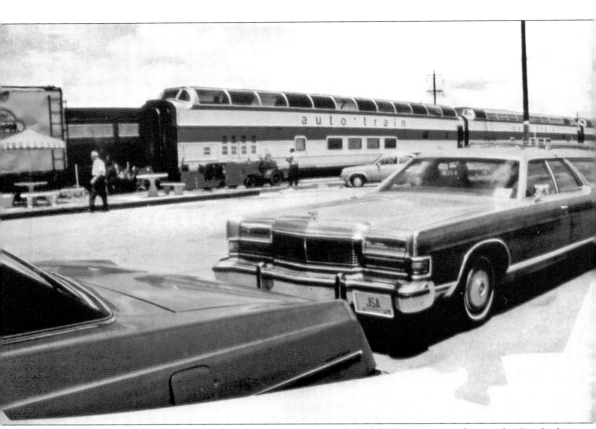

The Auto-Train always presented a picturesque image to behold. This picture taken at the Sanford terminal combines train full-dome coaches and arriving automobiles.

This caboose represents the end of the train . . . and the end of this book. Close the door on your sleeping compartment and have the attendant carry your luggage to the platform. Our trip together is over. Thanks for riding the Auto train with us (by way of this book!) It was fun being together with you through the history of this national treasure. Thank you for being a part of it. (Courtesy of Bill Folsom.)

DISCOVER THOUSANDS OF LOCAL HISTORY BOOKS FEATURING MILLIONS OF VINTAGE IMAGES

Arcadia Publishing, the leading local history publisher in the United States, is committed to making history accessible and meaningful through publishing books that celebrate and preserve the heritage of America's people and places.

Find more books like this at
www.arcadiapublishing.com

Search for your hometown history, your old stomping grounds, and even your favorite sports team.